Volume Seven

SPECIAL PAINTING TECHNIQUES

Volume Seven

SPECIAL PAINTING TECHNIQUES

Curtis J. Badger

STACKPOLE BOOKS

Published by
STACKPOLE BOOKS
Cameron and Kelker Streets
P.O. Box 1831
Harrisburg, PA 17105

Printed in Hong Kong

10 9 8 7 6 5 4 3 2 1

First edition

Cover design by Tracy Patterson

Interior design by Marcia Lee Dobbs

Cover photo: Rich Smoker burning a mallard wing.
Photographed by Curtis Badger.

Library of Congress Cataloging-in-Publication Data

Badger, Curtis J.
 Bird-carving basics.

 Contents: v. 1. Eyes — v. 2. Feet —
v. 7. Painting techniques — v. 8. Habitat.
 1. Wood-carving. 2. Birds in art. I. Title.
TT199.7.B33 1990 731.4'62 90–9491
ISBN 0–8117–2334–8 (v. 1)

Contents

Acknowledgments

This book could not have been possible without the cooperation of Jim Sprankle, Rich Smoker, Jo Craemer, and Grayson Chesser, who are not only talented artists but outstanding teachers as well.

These four artists make a good teaching team for the book because their methods vary widely—from exacting decorative painting to the looser tendering of gunning-style birds. Jim Sprankle is surgically precise in his method, while Grayson Chesser's gunning decoys need only enough detail to suggest a certain species.

The nice thing about bird art is that it can accommodate all of these methods and approaches. There is no right or wrong; what matters most is the individual artist's goals and motivation—what he or she hopes to accomplish with a carved bird and a little paint.

What I have tried to do in this book—and in the entire series—is to present you with a varied menu of options and let you choose the techniques that are right for you. You could call it an "à la carte" approach to learning bird carving.

The four artists whose work is included here have allowed me to look over their shoulders on many occasions, and they have shared with me not only the "how" of what they do but also the "why." So to Jim, Rich, Jo, and Grayson . . . thank you for sharing.

Introduction

Herewith is our first and most vital axiom of painting carved birds: Always plan your painting technique before your carving is begun, not after it is completed. Painting should complement a carved bird; it is not a separate and distinct step.

Jim Sprankle, for example, lays the groundwork for painting his meticulous decorative birds very early in the carving process. When he carves a feather split, he knows he will later enhance the split during the painting process by shadowing it with a thin wash of carbon black. When Rich Smoker carved the shallow dimples and feather swirls on the breast of his mallard drake, he did so with the intention of amplifying these carved features with paint. And this is what he does in chapter 4.

If your goal is to make gunning decoys, you won't spend as much time on detail and refinement. You'll want a painting technique simple enough that you can apply it to an entire rig of decoys without devoting your life to it, yet one that captures the essence of the birds being sought. The emphasis during carving is to capture a wild bird as simply and efficiently as possible, and this theme is carried through during painting. Grayson Chesser demonstrates this as he paints a rig of five Canada geese.

The point is that the painting technique you use is directly related to the type of carving you're doing. If your interest lies in the realm of realistic decorative carvings, you might want to try the techniques demonstrated by Rich Smoker, Jo Craemer, and Jim Sprankle, three leading sculptors of decorative birds. All use acrylic paints, which they find perfectly suited to highly textured wood carvings.

Acrylics are applied in thin washes and the color is built up through a succession of applications. This technique allows the fine texture lines to show through; thick oil paints would obscure them by filling in the shallow lines that replicate feather barbs and quills. And because acrylics are transparent, the artist can create subtle highlights and shadows and can provide the illusion of softness through techniques such as Jim's white-on-white demonstration.

If you are going to use acrylics, you will need to master three basic techniques: application of thin washes, color-to-water blending, and feather flicking. The three techniques are demonstrated by Jim and Rich in chapters 1 through 4.

When we speak of thin washes, emphasis should be placed on the word *thin*. "When in doubt, thin out," advises Jim. Truth is, you won't normally get into trouble by applying a wash that is too thin, but you can get into trouble pretty quickly by putting on a thick wash. The secret is to have patience and let the painting evolve slowly. The advantage of thin washes is demonstrated clearly in chapters 1 and 2.

Color-to-water blending is a fairly simple technique that gives a soft edge to a painted area. Basically, you dampen with water the perimeter of the area to be painted, then you apply the color and blend it to water along the perimeter. The technique produces a soft edge, which is important in almost every decorative painting project you will undertake.

Wildfowl artists use the term decorative to differentiate their carvings from the more utilitarian working decoys. I've never cared for the term because for me it conjures up images of mallards painted on rural mailboxes, of pintails used as table lamps. To me, the term doesn't do justice to the exquisite wood sculptures being produced by our best contemporary artists.

Indeed, there is probably little need today to differentiate between a bird carving destined for the display case and for the duck blind. Although many modern carvers make gunning-style decoys, or "slicks," few carvings ever come close to a duck blind. They are no less "decorative" than the most highly textured and detailed carvings intended for the gallery.

An anomaly is the work of Grayson Chesser, whose carvings are fully intended to be used. Grayson became involved in carving after becoming interested in duck hunting, so in his case, form truly follows function. His carvings are designed to be taken to the duck blind and used to entice passing waterfowl. They are weighted and balanced properly, and the leather line loop is intended to actually hold an anchor line.

If the truth be known, most of Grayson's carvings never see the water. For one thing, a hunter would have to be rather well-heeled to put together a substantial handmade rig, and for another, his decoys just look too nice on the mantel. I wouldn't want to see my Chesser black duck floating on a choppy bay or being stranded on a mud flat.

I went brant hunting with Grayson last year, and we used a rig of about seventy-five brant and Canada goose decoys, all made by Grayson. The rig was beautiful when the dawn illuminated it, and it occurred to me that the function of a work of art can be just as vital as its aesthetic beauty. By early afternoon the wind had picked up to more than thirty knots and the tide had fallen. Our decoy spread was floating in less than a foot of water, and when we tried to retrieve the decoys the wind threatened to pin our boat to the marsh. The bottom was too muddy for wading, a heavy chop was running, and the business of picking up seventy-five decoys was an ordeal.

Because the tide was falling rapidly and the wind showed no sign of slacking off, we had to get the decoys quickly. While Grayson maneuvered the boat through the chop, Cameron McIntyre and I retrieved the decoys. He used an oar to snag the anchor lines, and I used a gaff hook. In the hour it took to pick up the rig, decoys were bumped and battered, stepped on, hit by the boat hull, and generally treated anything but "decoratively."

To their credit, the decoys survived with only a few character-building battle scars. That none of the decoys was broken seems to me a greater testimony to Grayson's skill as a decoy maker than does the "shelf appeal" of his carvings. There was art in the way that rig functioned, and that's something a gallery could never capture.

Jim, Rich, Jo, and Grayson are all successful carvers and highly regarded artists, but their painting methods may or may not be right for you. We hope you will use their techniques only as a starting point and will then refine your methods to help you express something individual and unique through your work.

The danger of "how-to" books such as this is that they lead you to believe that because a well-known artist is successful, then his or her methods should be followed scrupulously. By presenting the work of very different artists in this series, I hope we can help you avoid this trap. Learning carving and painting techniques is like learning a language. You can learn vocabulary and syntax from a book, but your method of expression is yours alone.

1
Jim Sprankle
Painting White on White

Jim Sprankle is a former baseball player who spent more than ten years in the organizations of the Brooklyn Dodgers and Cincinnati Redlegs, and there is still something of the baseball player in him, some subtle quality that goes beyond the physical ability to throw a ball past a hitter standing sixty feet, six inches away from you. Sprankle is a perfectionist, a man who believes in discipline, dedication, precision, and the value of daily routine. He embraced these qualities while growing up in the Midwest, and when he signed that Dodger contract at age eighteen he realized that his fate in life depended on his willingness to wrench the maximum from his abilities.

You don't get to the big leagues by being sloppy. A few hanging curveballs and you're on the Greyhound back to Indiana. To be successful in baseball, and in life, requires attention to detail, mastery of countless small tasks. And so it is in bird carving.

Sprankle lives on an eighteen-acre waterfront spread on Kent Island, Maryland, just a few miles east of the Chesapeake Bay Bridge. His studio is a few yards behind the beachline, and in winter he can sit in his shop and watch the Canada geese gather by the thousands. An attached aviary contains canvasbacks, wood ducks, redheads, blacks, and pintails, all willing models for Sprankle's latest wood-sculpting projects.

In the past fifteen years, Sprankle has become one of America's leading wildfowl sculptors, winning blue ribbons in major competitions around the country. He and his wife Patty run a successful mail-order carving supply business, his books and videos on wildfowl carving are selling well, and there is a lengthy waiting

list for the summer workshops he holds at his bayfront studio.

Throughout his carving career Sprankle has specialized in lifelike waterfowl, and his aviary has enabled him to study every nuance of behavior and attitude. His carvings not only are exacting in detail, but they also convey much about the attitude and personality of the bird. "I think people are becoming very educated about what can happen structurally—attitudes and anatomy and so forth. So to do any major carving you have to have good reference. The first year after I had my aviary put in I won eight blue ribbons for different species. All of my carvings in the past seven or eight years have been derived from something I've seen in that aviary. The challenge for me is to do a creative piece, to work out first of all the composition, then the engineering. That's what I love about carving. The challenge keeps you crisp and eager."

In this session, Sprankle paints a bufflehead drake, demonstrating his technique for painting white

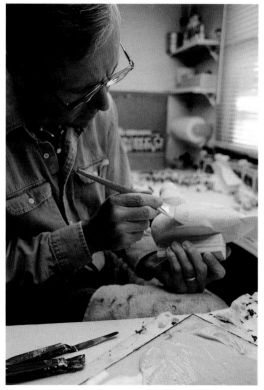

Jim applies gesso tinted with Paynes gray and raw umber. The object is to give the bird a slightly gray base coat on which the white feather markings will show clearly. Jim advises to always apply gesso with a stiff brush and work in the direction of the texture lines. Let the gesso air dry; it's a thick medium and if it dries too quickly, pinholes could develop.

on white, which is essential in depicting the subtle feather texture on the sides of the bird. If the sides were pure white, they would appear flat, two-dimensional, and uninteresting. The challenge is to add subtle values of white to the sides to give them depth and dimension.

"This is where acrylics are so valuable," Sprankle says. "By applying transparent washes of color, we can build up values and create depth."

Jim is demonstrating his painting techniques on one of the molded study birds sold through his mail-order company. If he were painting a wooden bird, he would first seal the surface with spray lacquer, then apply gesso as a base coat. Here he begins with applications of gesso tinted with Paynes gray and raw umber to produce a very light gray. When white feathers are added, they will show up against the gray background. Subsequent washes of white will lighten the gray base coat, bringing the feather details and the base color closer together.

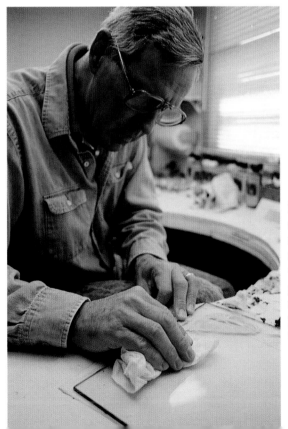

It is essential to keep your work area clean. If small particles of dried gesso or paint find their way to the surface of the bird, they will ruin the paint job. Jim uses a piece of plate glass as a palette, cleaning it often with Windex. A piece of white paper is used under the glass.

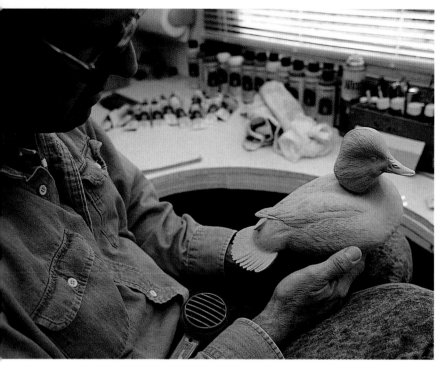

Allow the gesso to dry, then look carefully at the surface of the bird. The finish should be smooth and uniform, with no light or dark areas and no highlights. If a plastic filler was used around the eyes or neck, sufficient coats of gesso should be applied to cover and seal these areas.

The plastic study bird seals fairly easily. Jim emphasizes the importance of mixing the gesso and pigment thoroughly. Keeping records of paint ratios, including color samples, will make painting your next bufflehead drake much easier.

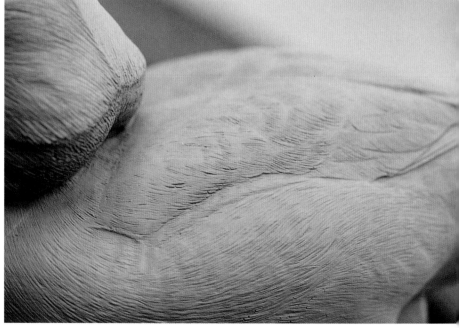

Three applications of gesso have sealed the study bird, and Jim is ready to paint.

He begins by using titanium white and a feather flicking brush to add feather edges to the sides and breast. The brush Jim uses has fan-shaped bristles. After each use, while the bristles are still wet, he flattens them with a palette knife and stores the brush so the bristles will remain flat. The white edges are added along the outside margins of the feathers carved into the bird. The flicking technique depends on having the correct water-to-paint ratio on the brush. Jim dampens his brush with water, picks up a little paint, and lightly brushes it along the edges of the feathers. If the brush contains too much water it won't fan out; if it is too dry the paint won't pull out of the brush. Practice this technique before applying it to a carved bird.

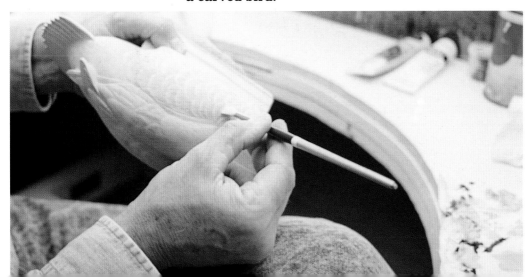

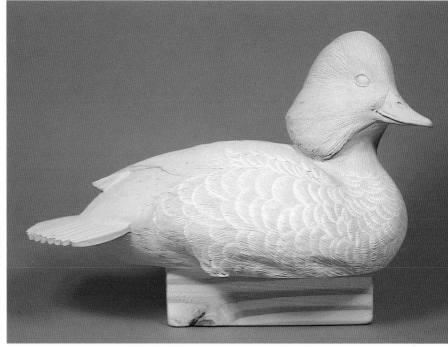

The bufflehead with feather details added to the sides and breast. Jim says a variety of brushes can be adapted to the feather flicking technique. He uses a size 6 Langnickel #99 and a Liquitex #511.

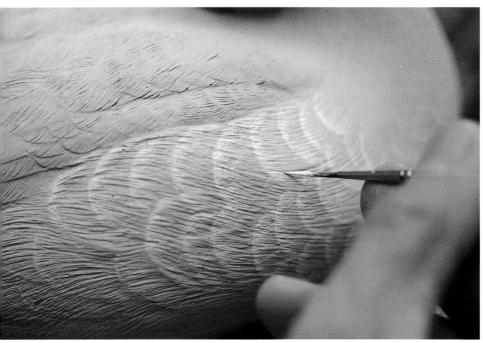

A small (size 0 or 1) brush can be used to extend the feather marks slightly or to retouch those that did not transfer well from the larger brush. Here Jim uses a size 1 lining brush to pull a little white paint through the feather markings.

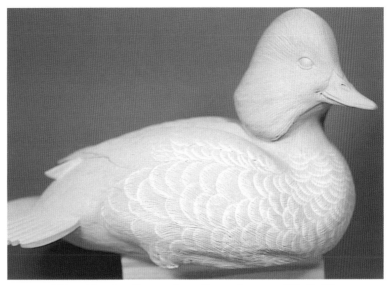

After the feather edges have been added, Jim applies several coats of a thin white wash. He first dampens the area around the sides and breast, then applies the white wash and blends the white into the water, producing a smooth, gradual transition. This carving has had one white wash. Several more will be needed to gradually lighten the area.

With four washes of white the feather edges have become very subtle but are still visible. "Sometimes it takes three washes, sometimes ten," Jim says. "The goal is to make the two values of white as close as you can but still retain some separation."

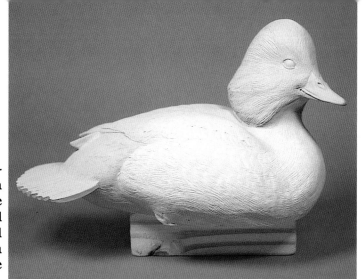

Notice in this photograph the difference in values between the sides of the bufflehead and the rump and tail feathers, which remain slightly gray, the original gesso color.

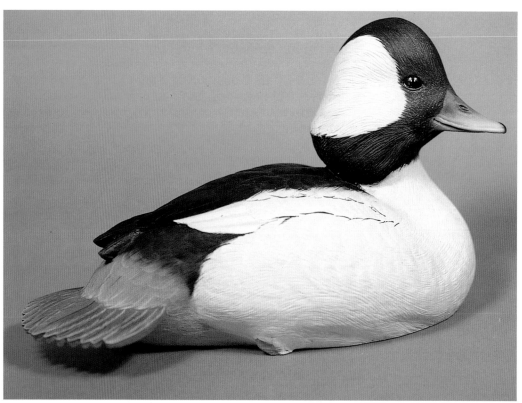

The completed bufflehead drake shows the white on white feather definition along the sidepockets. This subtle texturing adds depth and dimension to the bird, avoiding what Sprankle terms a ''paint by number'' look.

2
Building Color with Washes

Jim Sprankle

For more than twelve years, Jim Sprankle has used acrylic paints. "The beauty of acrylics is that you can apply them in very thin washes and slowly build up the values of color," he says. "You can apply one color over another, building depth and subtle shadings, and once you learn a few acrylic techniques, you can blend them very easily."

In this demonstration, Jim paints the head of a bufflehead drake, gradually building color through a succession of thin washes. The addition of pearl essence powder will add subtle iridescence to the head. (Alternatives to pearl essence powder are interference powder, bronzing powder, and iridescent powder.) Before painting the head Jim very lightly sketches with a pencil the margins of the white area. The dimensions of the white patch will vary depending upon the attitude of the bird. If the head is snuggled down into the body it will be smaller than if the head is extended or if the feathers are fluffed out. Consult your reference material before determining the size and shape of the white patch.

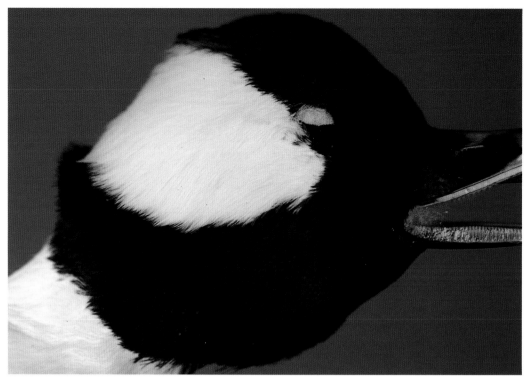

A taxidermy mount makes great reference material. Note the shape of the white patch on this bufflehead drake.

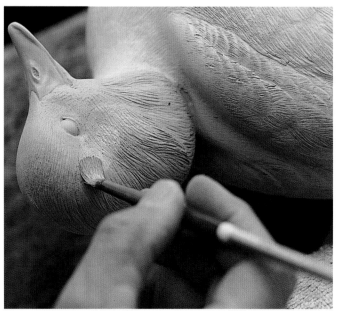

Jim dampens the outside of the white patch with water, then applies titanium white to the patch, blending the color to water along the margins of the patch to create a soft edge. Three or four washes of white will be applied.

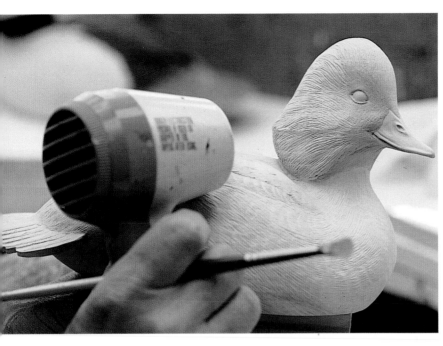

Although Jim doesn't use the hair dryer on a thick medium such as gesso, he does use it when applying washes of color. It speeds up the drying time considerably.

Now Jim applies a mixture of Hooker's green, phthalo green, and mars black to the face of the bufflehead. He dampens the crown and throat of the bird with water before painting, blending color to water. A small lining brush creates the transition between green and white.

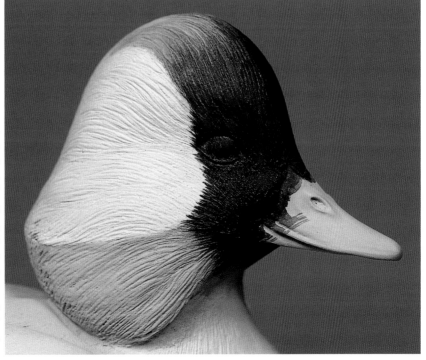

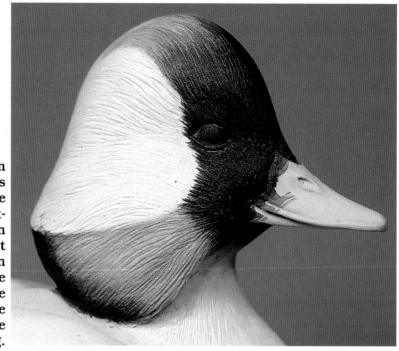

Iridescent green pearl essence is added to the green paint mixture to add depth to the color. Don't worry about green spilling onto the bill, because the bill will be gessoed before painting.

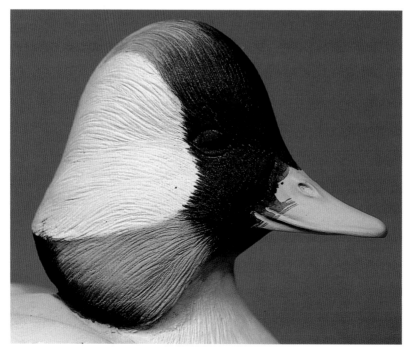

With three washes, the green looks good. It should be slightly darker behind the bill and just over the eyes.

Jim paints the crown of the head and the lower cheek with Grumbacher purple, to which has been added a small amount of mars black. He dampens the green areas with water and blends the purple into the water, overlapping the dried green paint.

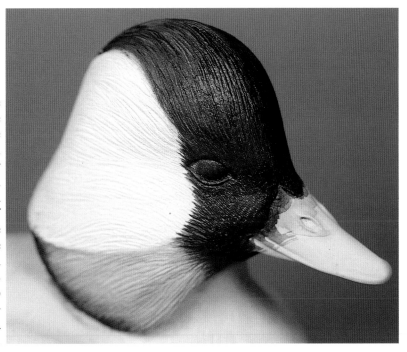

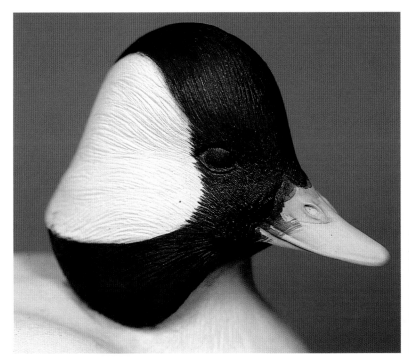

Two washes of purple have created good coverage, but the transition between the purple and green is still somewhat abrupt.

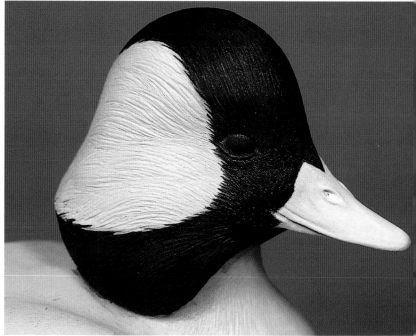

Four washes each of purple and green have been applied, and the colors look rich and deep. Jim has painted the lower cheek of the bird and applied a coat of gesso to the bill in preparation for painting.

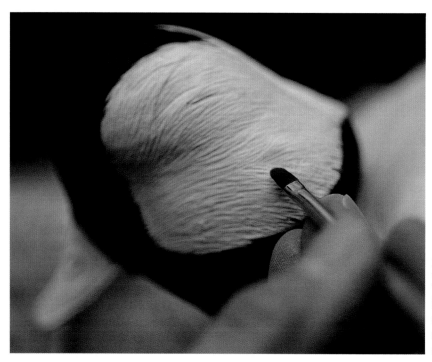

A light wash of Paynes gray over the white patch soaks into the valleys of the texture lines and gives them definition.

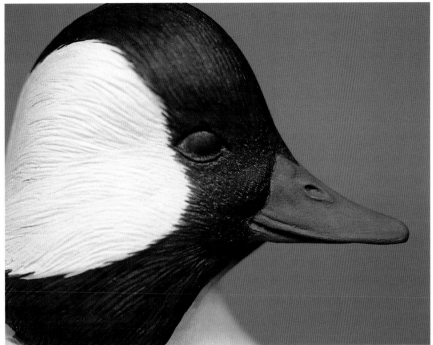

Jim paints the bill with a mix of titanium white, Paynes gray, and raw umber. He mixes three values of paint: dark gray, medium gray, and light gray. He begins by applying dark gray to the entire bill.

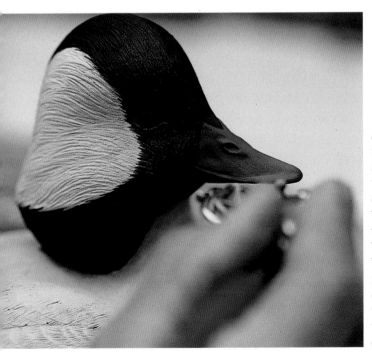

Jim uses the airbrush to add the medium value of gray along the margins of the bill. The lightest value is used on the tip. These colors could be brushed on in successive washes. The color of the bufflehead bill varies from bird to bird, so check your reference. There is no exact color formula. With the tip of the bill lightened, Jim uses the airbrush loaded with carbon black to add the nail.

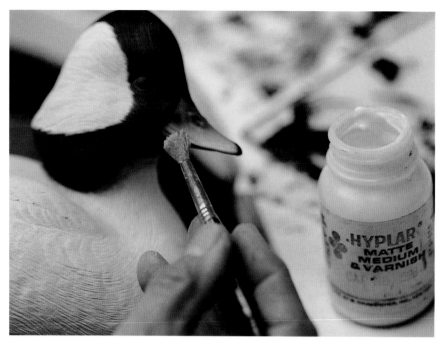

An application of matte medium and varnish gives the bill a slightly moist, lifelike look.

The completed bufflehead drake head. Note the depth of color provided by repeated thin washes and the subtle blending where the dark green meets the purple. A final thin wash of carbon black has added definition to the white patch by slightly darkening the valleys of the texture marks.

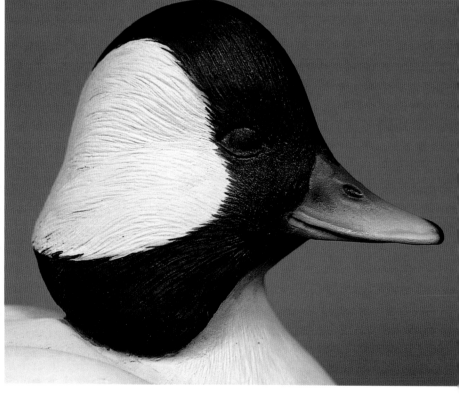

16

3

Rich Smoker
Using Paint to Suggest Texture

Although Rich Smoker is a highly regarded carver of decorative waterfowl, his artistic roots are in the hunting tradition, and each year he makes several dozen handsome "slick" decoys for friends and customers. Rich appreciates the tradition of making hunting-style decoys, particularly the artistic challenge of using a minimum of detail to make a bird appear realistic. In this session he does just that, using paint to indicate feather texture on a black duck gunning decoy.

Rich grew up in Selinsgrove, Pennsylvania, and developed an interest in waterfowl while hunting ducks on local ponds and along the Susquehanna River. A need for hunting decoys led him and his father to carve a rig of black ducks, mallards, and canvasbacks while Rich was in high school, although his goal at that time was not a career in carving but in the related field of taxidermy.

After high school, Rich entered an apprenticeship in taxidermy and in 1979 opened his own business. Ironically, he began carving birds just as he was launching his taxidermy business, spending his slack season working with the carving tools.

"Other than that first hunting rig, I made my first decoys for a contest in 1979 and began my first decorative a year later," he says. "I realized I could carve decoys, but I couldn't carve them the way I wanted to, so I kept working at it. I knew the anatomy of the birds through taxidermy. I knew what they looked like from the inside out, but it was hard for me to take a piece of wood and make them look right from the outside in. I had no art education or background. I learned about

mixing paints and using an airbrush in taxidermy training. When I finally discovered that carving had a lot in common with taxidermy as far as the sculptural aspects are concerned, I realized that carving wasn't as hard as I thought, and I began doing more of it and began to sell some."

Rich and his family moved to Crisfield, Maryland, in 1983 and he began to spend more time carving and less time doing taxidermy. In 1985 he quit taxidermy completely, except for preparing his own study skins.

Since 1979 Rich has won more than 230 ribbons in such competitions as the Ward World Championship in Ocean City, Maryland; the Mid-Atlantic in Virginia Beach, Virginia; the Havre de Grace and Chestertown shows in Maryland; the spring and fall shows in Chincoteague, Virginia; and numerous others. His decorative carvings and gunning decoys are in collections around the world.

In this session, Rich uses a variety of color values to suggest texture on the head of a black duck decoy. The bird has been carved in the simple, untextured manner of traditional decoys, but Rich wants to use paint to add the impression of texture and depth on the bird's head.

He begins with a coat of white gesso tinted with black and raw umber to create the light base color for the face. The darker chocolate color used on the crown is a mixture of white gesso, black, burnt umber, and burnt sienna. Rich uses an airbrush to create soft transitions between the light and dark areas and to paint the dark lines between the eyes and bill.

Rich will begin detailing the head with a small brush, which he uses to paint burnt umber feather detail. He will add several white feather lines as an accent and then will partially cover that detail with a wash before adding more feather detail. This technique is used not only to create texture, but also to build the illusion of depth; the feather lines beneath the wash are muted, while those on top are bold.

The technique can be varied to create either a light or dark head depending on the number of washes, the proximity of the feather lines, and the values of the colors used. Rich says the black ducks he used to hunt in Pennsylvania have much lighter heads than blacks on the Eastern Shore of Maryland. "When

I first took some of my Pennsylvania black ducks to a local exhibition they laughed me out of the auditorium," he says. "No one painted black ducks with heads as light as mine. So now I paint them darker. When in Rome . . ."

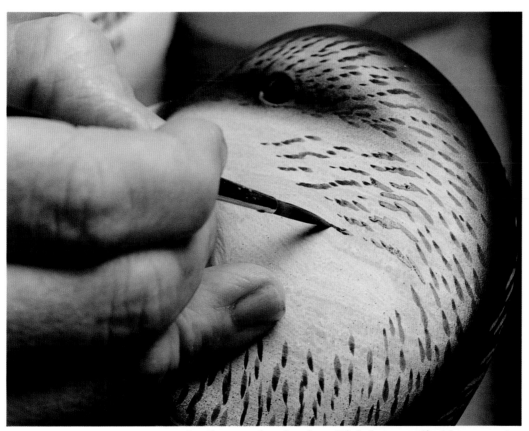

As the session begins, Rich has applied base coats to the head of the bird. The cream base color is white gesso tinted with carbon black and raw umber. The chocolate color applied to the crown and eye channel is a mix of white gesso, black, burnt umber, and burnt sienna. The chocolate color was applied with an airbrush to create a soft edge. Now Rich begins applying the base feather pattern using burnt umber on a small (size 0 or 1) sable brush.

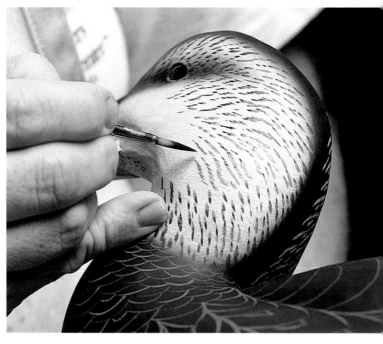

The feather marks are applied in a flowing pattern, roughly duplicating the curve of the neck. Applying the marks close together will produce a dark head; leaving more base color between the marks will yield a lighter head.

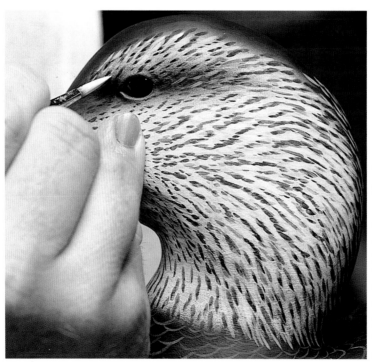

After applying the dark feather marks with burnt sienna, Rich mixes some warm white and raw umber and applies light feather marks between and over the burnt sienna lines. The combination of light and dark texture marks will help create depth.

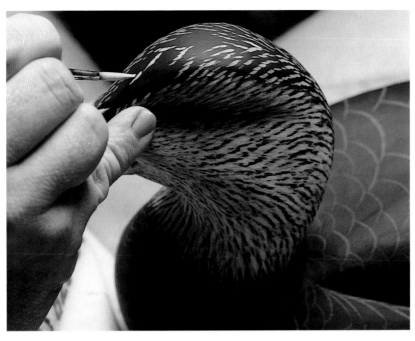

The same warm white and raw umber mix is used to add feather detail to the dark crown of the head.

A wash of white and raw umber is applied to the entire head, toning down the bold design. Rich uses the airbrush to apply the wash, but it could easily be done with a brush. Dilute the color with water and apply several thin washes, allowing the color to build to the value you want.

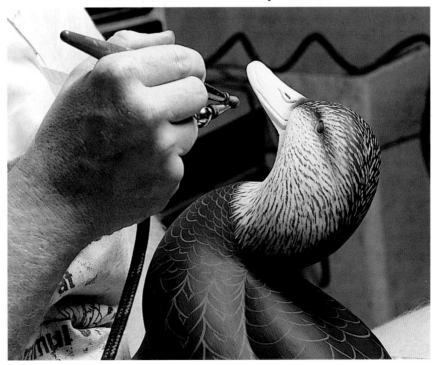

During this process, Rich adds highlights to the cheeks and the area of the face at the base of the bill. The highlights emphasize cheek contour. If you're using a brush, you can create highlights by applying one or two additional washes in these areas.

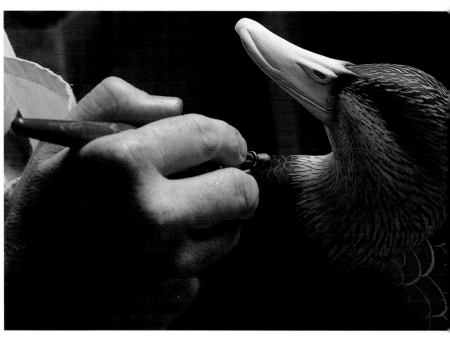

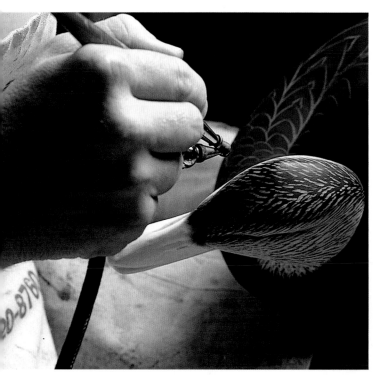

Now Rich loads the airbrush with burnt umber and applies a wash to the crown of the head to tone down the cream-colored feather detail.

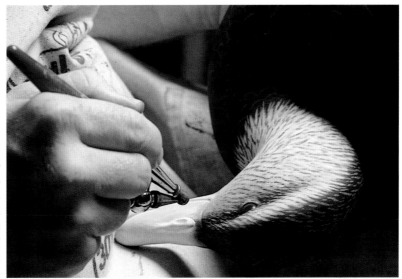

The airbrush is used with burnt umber to create a gradual blend between the dark crown and the highlights along the face of the bird.

With the washes completed, Rich again applies feather detail, this time with a mix of white, raw umber, and raw sienna to produce a yellowish cast. This step, Rich says, is in deference to his Eastern Shore friends who are used to seeing black ducks with a dusky-colored head. The birds' heads are darker, Rich speculates, because they feed in brackish marsh water high in iron content.

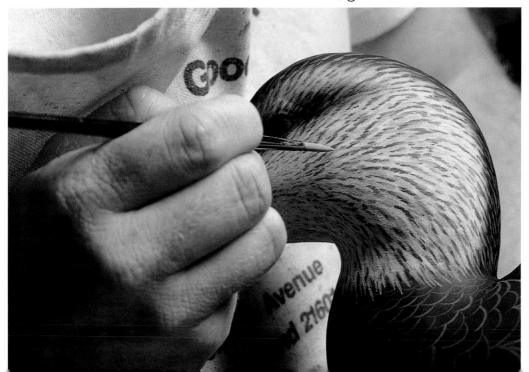

Now another application of burnt umber goes between the strokes of raw umber and raw sienna. These bold marks, applied over the wash of warm white, add depth to the pattern by combining subdued detail with bold surface feather patterns.

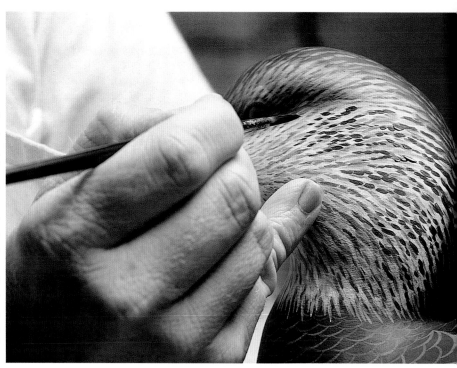

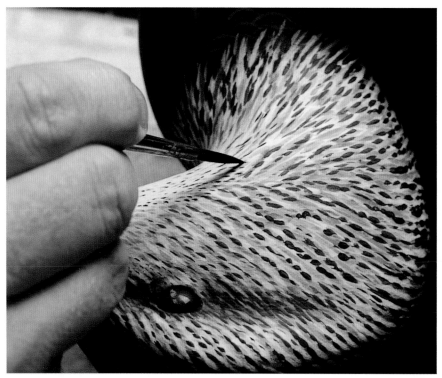

In the following steps, Rich will continue this process of painting bold feather detail, subduing it with washes, then applying more detail. The technique creates a three-dimensional effect. Here he uses a small brush to add burnt sienna markings.

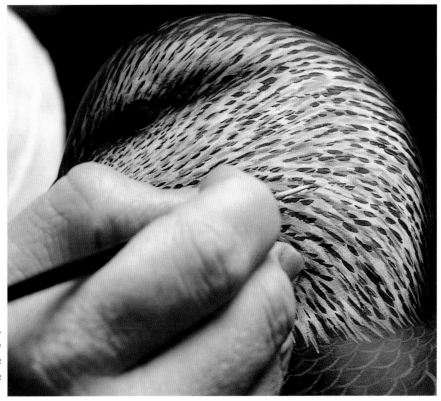

And now the warm white is used to create hairline detail along the side of the head.

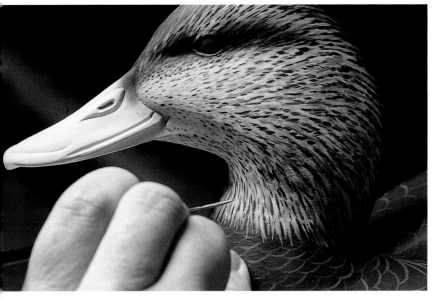

The white is used along the neck of the black duck to paint the transition area between the chocolate base coat of the body and the lighter color of the head.

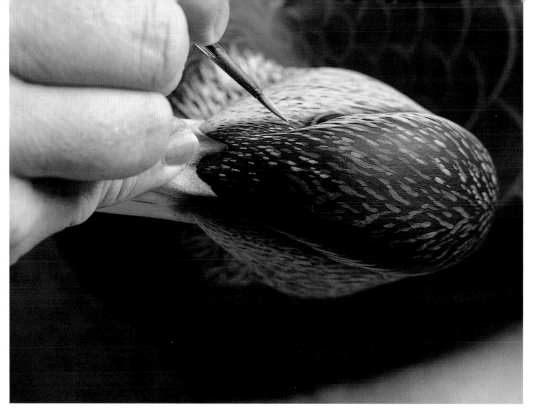

Rich uses the warm white again on the crown of the head, applying small feather marks between the original white strokes that have been subdued with the burnt umber wash. Do not cover the original marks; they help produce the desired depth.

Now carbon black is applied to produce an even bolder look. Rich puts the marks closer together along the eye channel to maintain the dark stripe that begins at the corner of the bill and extends through the eye toward the back of the head.

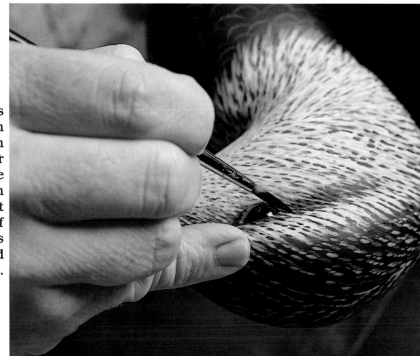

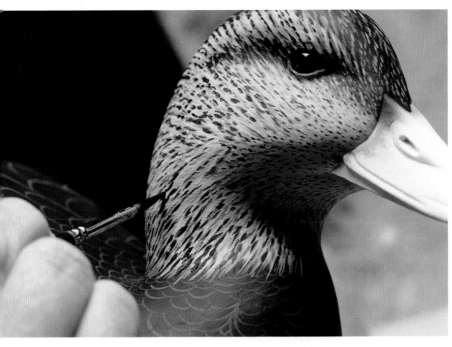

The black marks are applied along the neck, leaving the highlight along the cheek a suitably lighter value.

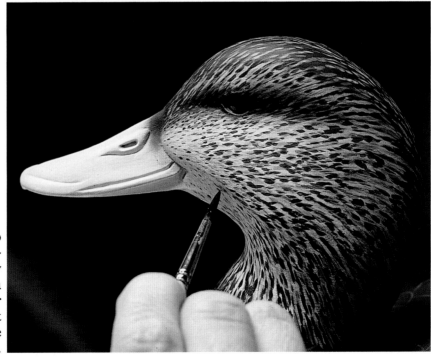

Black marks help darken the area behind and below the bill. Rich then applies another very thin burnt umber wash to the head.

Then the small brushes are used to add bolder feather detail with short strokes.

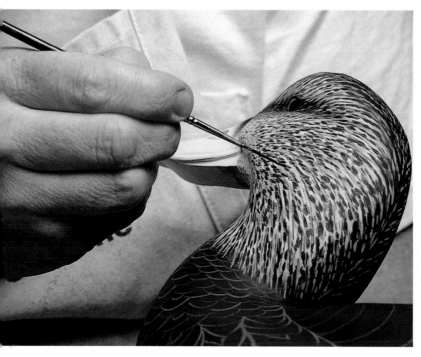

Longer strokes are used to bring the design together and to create an overall flow pattern along the neck.

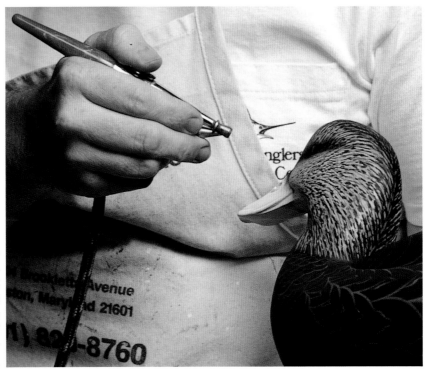

The airbrush is again used with a thin wash of burnt umber to darken the head, bringing the color values of the feathers closer together.

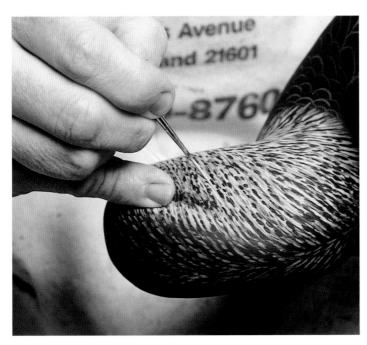

White highlights are applied over the burnt umber wash to produce a final layer of detail.

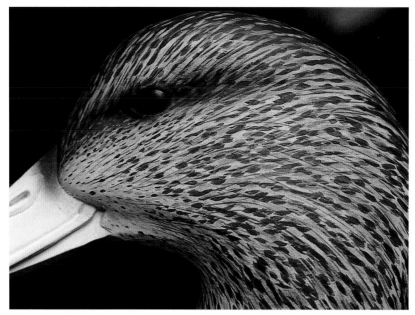

This close-up photo shows the layering of color and detail. The subdued detail applied early in the painting process still shows through, while feather strokes applied later are bolder, creating an illusion of depth and dimension.

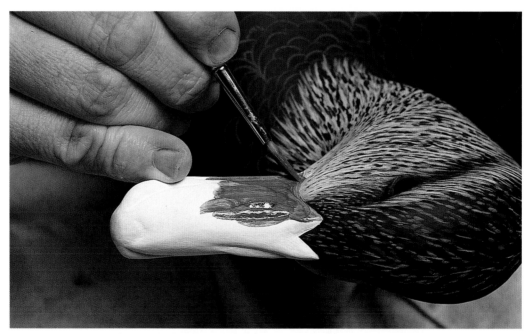

Rich completes the painting process by painting the bill. First he applies a coat of gesso to cover paint that spilled over onto the bill, providing a uniform surface to which color will be applied. The bill color is a mix of Winsor & Newton olive green and Liquitex yellow oxide. Rich applies the base coat with a brush, beginning at the base of the bill.

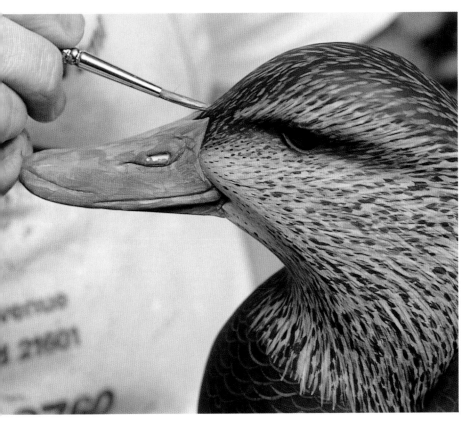

A darker version of the same mix, made by reducing the yellow oxide content, is used to create shadow areas in the shallow depressions along the bill.

A lighter version of the bill color, with more yellow oxide, is used in the airbrush to lighten the tip and sides of the bill to give it a bit more contrast.

The very tip of the bill will be lightened even more with yellow oxide just before the nail is painted.

Rich uses mars black to paint the nail and the nostril holes.

Jo Sonya sealer diluted ten-to-one with water is applied to the head and the entire bird to make the acrylic paint waterproof. Rich applies the sealer in two to three coats.

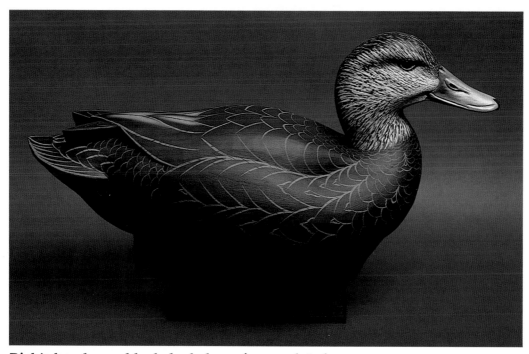

Rich's handsome black duck decoy is completed,
with the head textured by repeated applications of
painted detail and washes.

4
Rich Smoker
Painting the Breast of a Mallard Drake

Although a carved bird is a three-dimensional object with plenty of contours to produce highlights and shadows, it frequently is necessary to enhance these subtle visual elements with paint. The breast of the mallard drake, for example, is a dark burgundy color, and although the curve of the breast should produce a suitable highlight under normal lighting conditions, Rich is going to enhance the highlight with paint to accentuate the contour of the carving.

Adding subtle highlights is a fairly simple task with acrylic paints, thanks to their transparent nature and their ability to build depth and richness of color through a succession of thin washes. Rich will first apply a light value of the breast color in the area where a highlight would normally fall. He then will cover the area with several washes of the darker burgundy, bringing the value of the highlight and the surrounding areas closer together. After two or three washes, the highlight still remains visible, but it is very subtle; the viewer knows it's there, but it is not immediately apparent. It simply enhances the normal highlight.

Rich will add further interest to the mallard breast by applying small feather splits—little dimples that make the breast appear soft and fluffy, as if made of feathers, not wood. He will finish by adding subtle feather edges, which further soften the appearance of the breast by adding depth and detail.

Of course, Rich could paint the mallard breast with just a few coats of the proper color and let it go at that. But to do so would negate all the hours he spent with the texturing tools during the carving process. The painting step should build on the form and texture created during carving, not take away from it.

35

Subtle painting techniques such as creating highlights and painting feather splits and feather edges heighten the illusion of texture and enhance the form of the sculpted bird. In many respects, painting a carved bird is similar to the trompe l'oeil process used in architecture. Your purpose is to "fool the eye." When someone touches one of your carvings, you want them to expect a soft, pliable surface. The mind might say wood, but the eye should say feathers.

Before painting the bird, Rich seals the wood surface with a base coat of gesso tinted with a little burnt umber. He paints the breast with a combination of burgundy, burnt umber, and brown earth to produce a reddish chestnut color. Rich mixes the colors on a sheet of glass, being careful to maintain a clean work area. Experiment to determine the proportions of the three colors. This is a three-quarters scale bird, and Rich uses a slightly brighter mix on smaller carvings, so he adds more burgundy to the mix than he normally would.

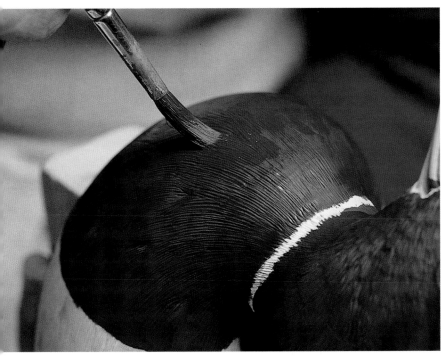

The paint is applied to the breast in a succession of washes. Each is dried with a portable hair dryer before another is applied. Here Rich applies the third base wash. He is using Jo Sonya acrylic colors.

The hair dryer speeds up the drying time considerably. The dryer is fine for diluted acrylic paints, but avoid using it on a thick medium such as gesso. If gesso dries too fast, pinholes and blisters could develop.

404 Brookletts Avenue
Easton, Maryland 21601

(301) 820-8760

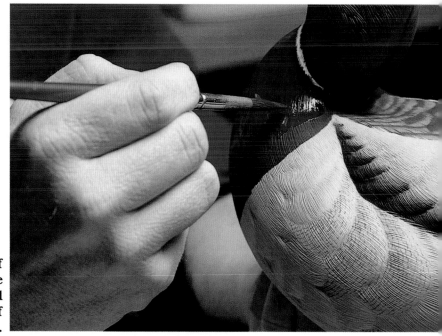

A fourth wash of the burgundy base color is applied to the upper part of the breast.

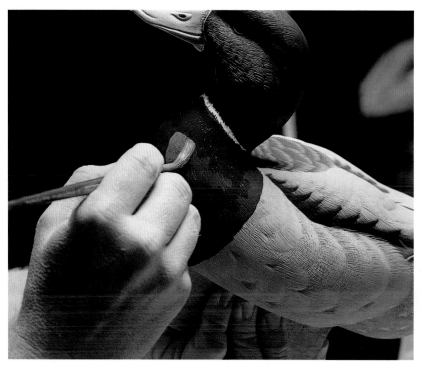

Rich begins painting a band of highlight across the breast by first applying the base color along the outer edges of the highlight, then painting the center of the area with the same base color lightened with white.

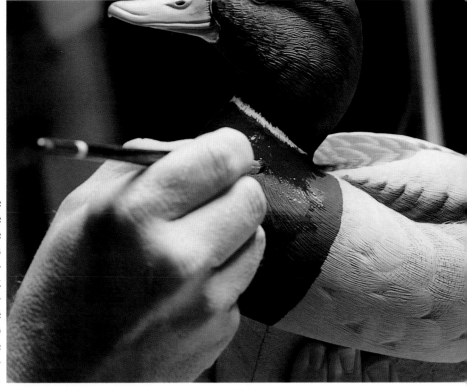

The edges of the base color and the highlight are then blended. It's important to apply the base coat outside the highlight area so the edges of the two colors can be blended, producing a soft edge.

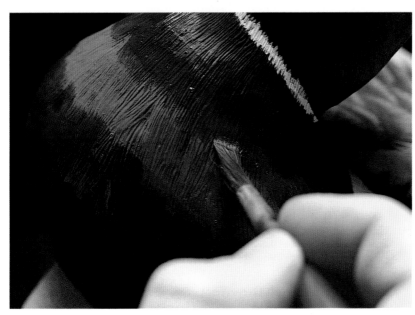

Now Rich repeats the process, applying the dark base color around the highlight.

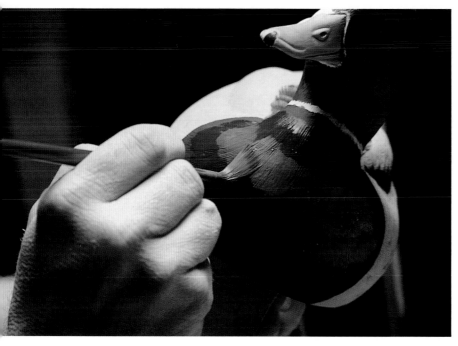

In this step
a second wash of
the highlight
color is added.

The breast is dried, and Rich evaluates the effect
of the highlight. He decides to apply a third wash.

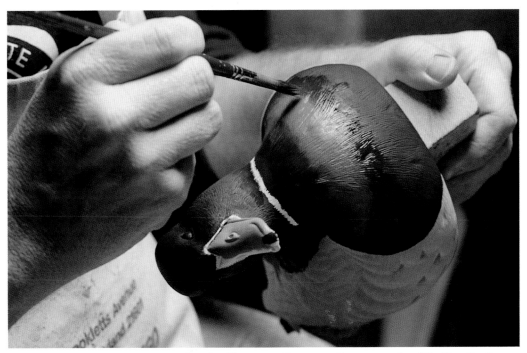

Again the margins are dampened with the dark base color mix, then the lighter color is used along the highlight band.

As the paint dries, the highlight becomes very subtle. The highlight should enhance the contour of the mallard breast, but it should not call attention to itself.

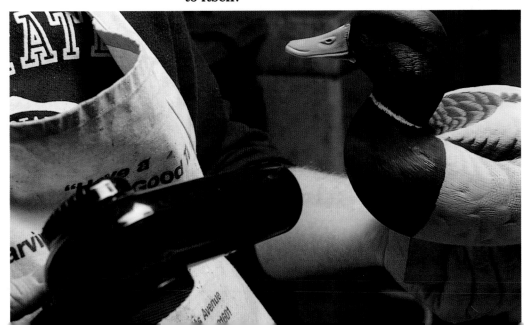

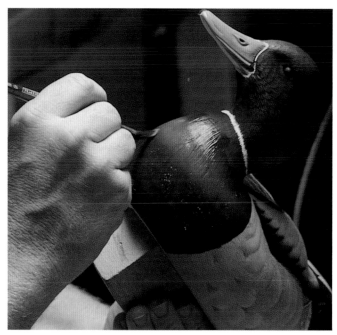

Rich will make the effect even more subtle by applying a thin wash of the burgundy base color over the entire breast. This step will bring the value of the highlight even closer to that of the surrounding area. If the highlight appears too light, apply enough thin washes of the darker base color to tone it down sufficiently.

And now Rich will enhance the V-shaped feather splits added during the carving process by highlighting them with the same paint he used for the broad highlight band. The lighter value is applied to the inside of the feather and the darker value below it on the outside. Rich uses two brushes: a size 0 or 1 lining brush to apply the light color, then a larger one to apply the dark base color.

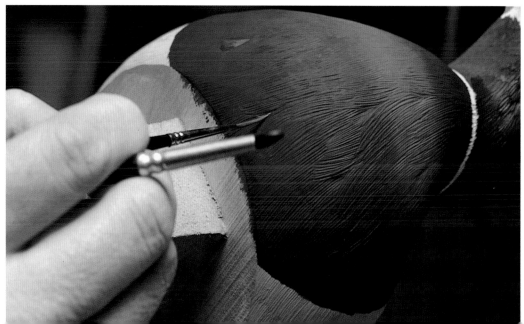

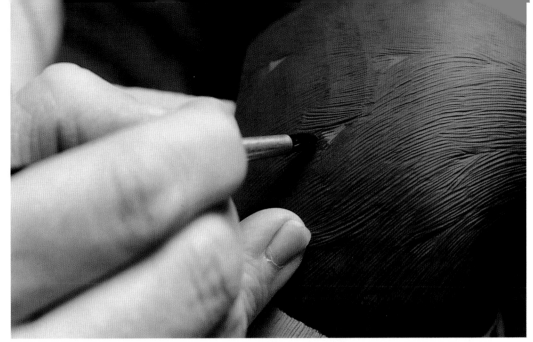

Rich has applied the light color to the inside of the V. Now he uses the larger brush to blend the dark color into the lower portion of the highlight. He wants to give the impression that the top layer of feathers has split apart, exposing the feathers that lie below. Compare the highlighted feather splits with the textured splits that have not yet been painted. In painting decorative birds, the painting process should complement and expand on the detail added during carving. This is a good example.

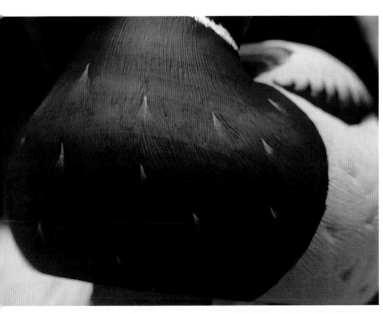

The feather splits have now been highlighted. If the highlights are too light, a thin wash of the burgundy base color can be applied over the entire breast. Note the direction of the texture lines and the manner in which they create splits and dimples. These features help provide the illusion of softness and loft.

And now Rich will outline the feather edges of the breast with burnt umber. Individual feathers were not carved on this bird, only the textured lines seen in previous photographs. The burnt umber marks, applied with a size 6 fan-shaped brush, will simulate individual feathers.

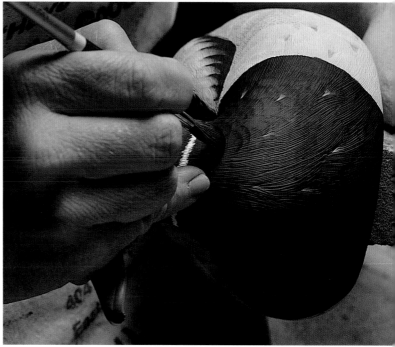

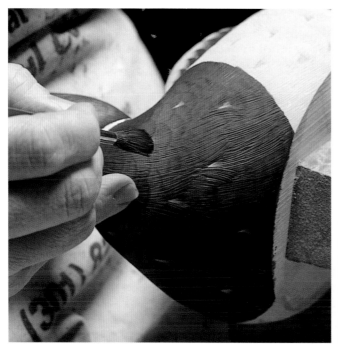

The feather edges are darker and closer together near the base of the breast and are farther apart near the neck. Carbon black is added to the burnt umber to slightly darken the paint near the base.

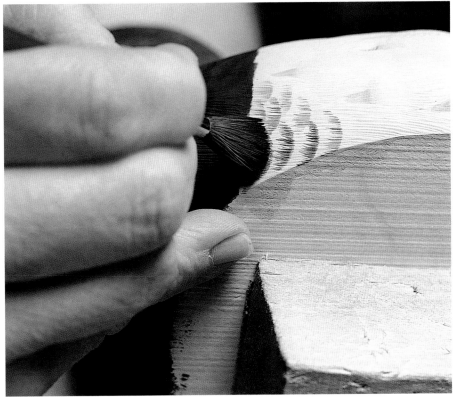

The burgundy base color, darkened with a little burnt umber, is used to add feather edges along the lower portion of the breast where it meets the sides.

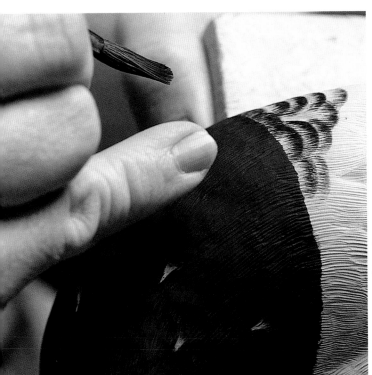

These feather edges will soften the margin between the breast and sides, providing a gradual transition.

45

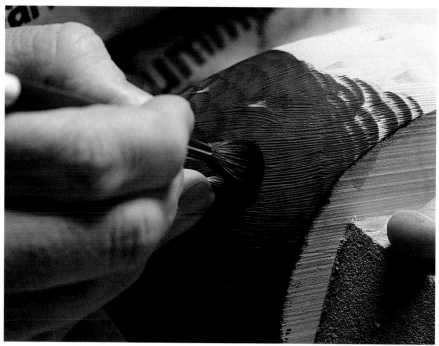

Next the bottom of the chest is blended into the sides by adding darkened feather edges, which are a combination of the burgundy base color and burnt umber.

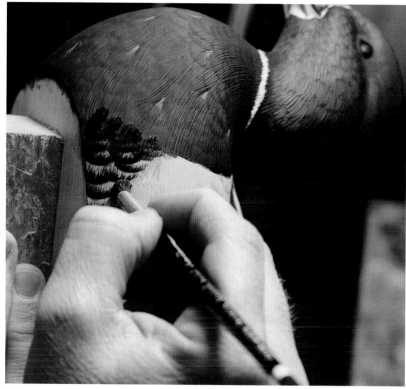

Burnt umber mixed with black is used to further darken the feather edges along the transition area between the breast and sides.

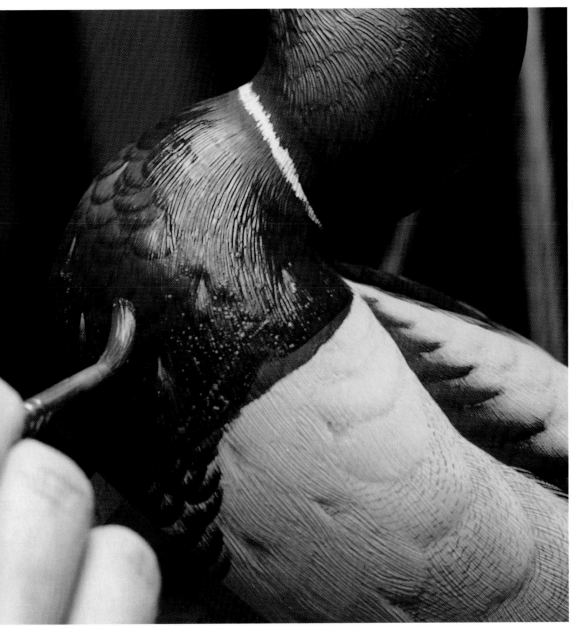

A thin wash of burnt umber is applied over the
entire breast to darken it and to bring the values
of the base color and highlights closer together.
The hair dryer is used to dry the final color wash.
If the highlights are too apparent, a second or
third wash of burnt umber could be applied.

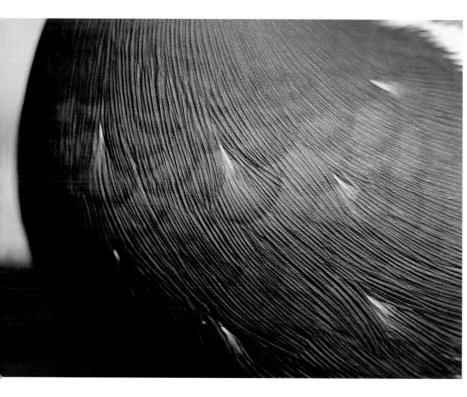

This close-up of the finished breast shows the highlight, the feather splits, and the painted feather edges. These techniques give the painted surface the illusion of softness and depth, and they emphasize the contours and the carved detail.

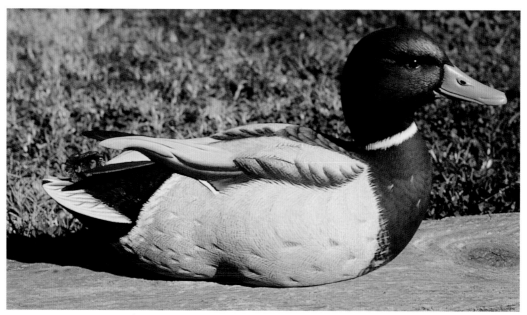

The completed mallard drake.

5
Painting an Orchard Oriole

Jo Craemer

A male orchard oriole is a good subject for beginning painters because it has a fairly uncomplicated color pattern that does not require a great deal of technical virtuosity. Jo Craemer will paint the bird using only six colors: Liquitex acra gold, Liquitex burnt umber, Liquitex cerulean blue, Liquitex titanium white, Hyplar ultramarine blue, and Speedball warm black, a graphic arts paint.

The bird has been carved in tupelo gum and has been textured with a high-speed grinder and a burning pen, an instrument with a heated, knifelike blade that can replicate fine feather texture. "I tend to texture my carvings fairly heavily because it makes painting easier," says Jo, a retired U.S. Navy nurse who lives near Georgetown, Delaware. "Some of the outstanding artists, such as Bob Guge, texture very lightly and add the feather detail with paint, but it takes a great deal of talent to do that. I prefer to add the texture during the carving process and apply the paint in thin washes, letting it soak into the grooves of the wood. For me, it's easier this way. The bird almost paints itself."

Before painting, Jo assembles all the reference material she can muster. She visited the Smithsonian Institution in Washington, D.C., to inspect a study skin of the oriole, and she collected all the photographs of orchard orioles she could find. Not surprisingly, the photographs showed a wide range of colors, especially in the chestnut area seen on the breast and back. In some photos it was a yellowish gold, and in others it was a deep chestnut. In such cases, some artistic license is allowed, and, indeed, required.

"The best reference, other than a live bird, is a study skin," says Jo. "Photographs vary in color depending upon the direction of the light and the time of day, but a study skin can give you an exact read not only of colors but also of the design of feather groups and placement of fine detail."

It's important when working with acrylic paints to have a clean work area. If you paint in the same room where you carve, be sure to vacuum up stray dust particles, which could ruin a fine paint job. Jo begins by having the tubes of color she'll use close at hand, her porcelain mixing trays clean and ready, a supply of clean water on her work table, and her reference material assembled.

Before painting, she will seal the bird by dipping it in a mixture of one-third lacquer and two-thirds lacquer thinner. By dipping the carving in the solution, Jo makes sure the lacquer gets well inside the deeply carved texture lines, sealing the pores of the wood. "You can use a spray lacquer," she says, "but this method ensures the wood is completely sealed. I clean all the dust off first, then immerse the carving in a jar of lacquer solution for about a minute. I learned the technique from Ernie Muehlmatt, and he learned it from John Scheeler. It's unusual, but it works nicely. The intent with this step is to waterproof the bird. If you apply water-based acrylic paints to bare wood, you will raise the grain of the wood and all that finely carved detail will be lost."

When the lacquer dries, she lightly sketches the color pattern of the bird and applies white gesso as an undercoat where the chestnut gold paint will go on. "Some painters don't use gesso and others swear by it," she says. "I like to use it because I burn detail fairly heavily, and burning compresses the wood fibers and makes the surface of the wood relatively slick. Sometimes acrylic paints tend to run off instead of adhering to the surface. Gesso provides a good base for paint because it is a fairly thick medium that dries with a slight texture."

While painting, it is important not to handle the bird too much with bare hands because oils can be transferred from the skin to the wood and interfere with paint adhesion. White cotton gloves can be used, or the bird can be attached to a handle. Jo uses the

latter method, attaching a wooden dowel where a leg will later be mounted. Jo epoxied a wood screw to the tip of the dowel and attached the dowel at the same angle at which the leg will be inserted. If you must handle the bird with bare hands, make sure they are clean. An unpainted, gessoed surface can be cleaned with a light application of window-cleaning spray dabbed dry with a soft paper towel.

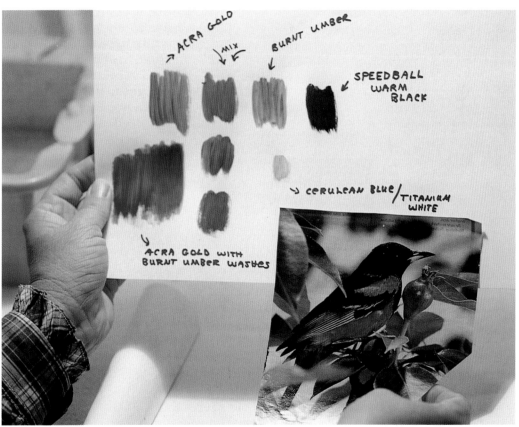

Jo begins by assembling reference photos to help determine color and design, and she has her paints and brushes ready. In painting the orchard oriole she will use only six colors, five of which are shown on the above test chart. Liquitex acra gold, with a wash of burnt umber, provides a pretty good match for the chestnut color of the oriole.

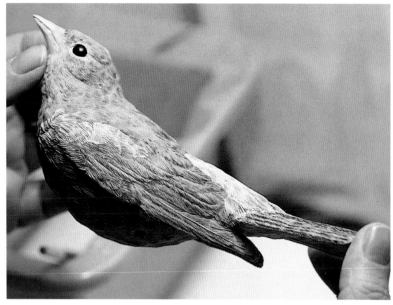

After sealing the carving with lacquer, Jo applies white gesso where the chestnut gold color will be applied. "Acrylics are transparent, and if I painted gold over the darkened wood, the value of the color would be too dark," she says. "The white base color will add some brilliance to the gold value. I don't put gesso under the black areas because it's not needed."

The black area will be painted first, then the chestnut gold breast and back. Jo uses a Langnickel Sunburst series 2020 size 4 brush and dabs black paint in the centers of the feathers. The edges will be lighter, so Jo leaves them unpainted for now.

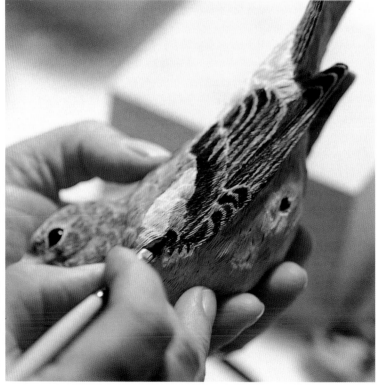

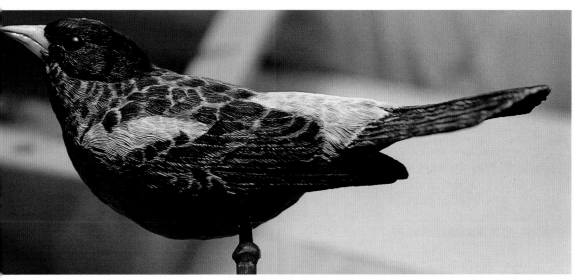

The black is applied over the entire head and on the wing and tail feathers. After one application, the oriole looks like this.

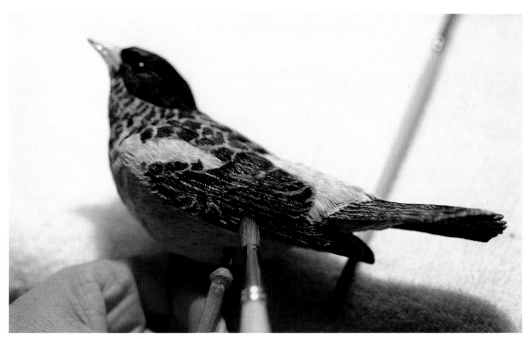

Jo goes over the black area again, applying a second thin wash to the centers of the feathers and to the head.

The paint is dabbed on with the Sunburst brush, which has both sable and synthetic bristles, a good combination for applying acrylic paints. Sable bristles alone become "waterlogged," Jo says, but the addition of synthetic fibers helps maintain firmness without sacrificing the capacity of the brush to carry paint.

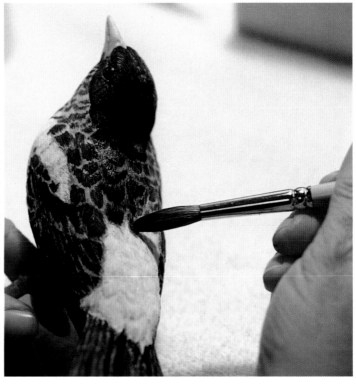

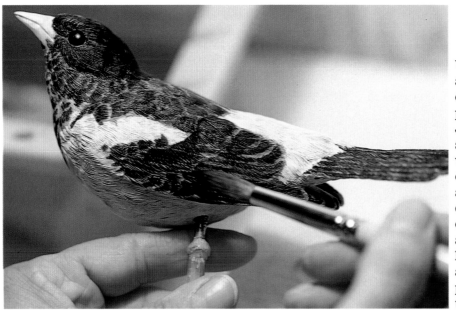

With the head and the centers of the feathers painted black, Jo now applies several thin washes of black over the entire area. This will darken the area overall, leaving a slightly lighter value along the unpainted edges of the feathers.

With the black areas painted, Jo prepares to paint the chestnut gold body of the oriole. She adds acra gold to a section of her palette, then dilutes it with water in a neighboring compartment. It's important to dilute acrylic paints with water and let the color build up in a succession of washes. "You can't take it off once it's on," Jo says. "It's much easier to work your way up to a final coat."

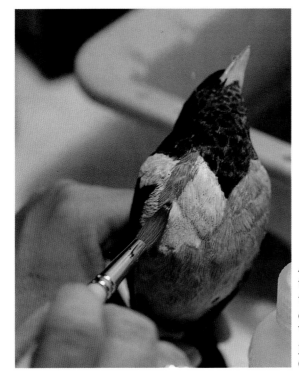

A wash of acra gold is applied over the white gesso. Jo uses a very thin wash, letting it soak into the carved texture lines of the bird. When the first wash has been applied, Jo dries it with the hair dryer.

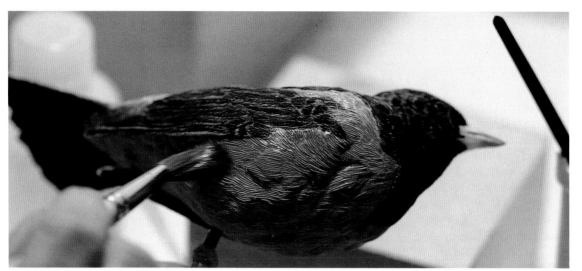

And now a second wash goes on, deepening the value of the gold color. The color will be darkened further by subsequent washes of burnt umber and gold.

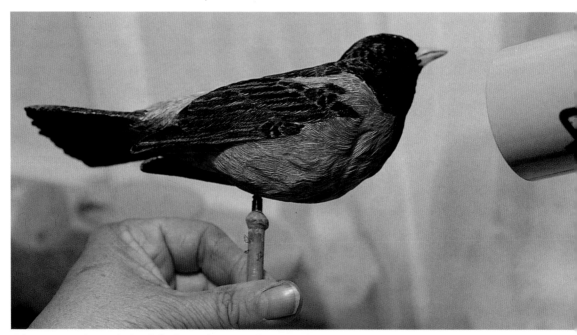

The second wash is dried, and Jo evaluates the color, checking it against her reference photos. The chestnut gold varies a great deal from bird to bird, so Jo has some leeway in determining the exact value of the color.

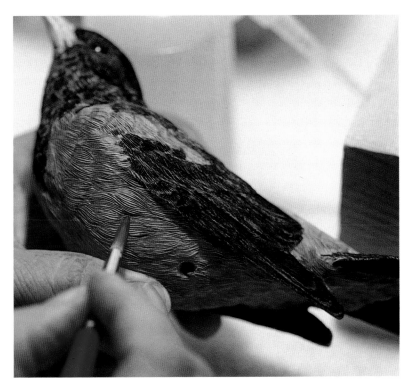

She decides to add a very light wash of burnt umber to the edge of each feather, which will help emphasize the contours of the feathers by darkening the deep texture lines.

And now another wash of acra gold is applied to the breast, creating highlights. "I alternate washes of gold and burnt umber," Jo says. "The burnt umber emphasizes the shadows while the gold adds richness to the highlights."

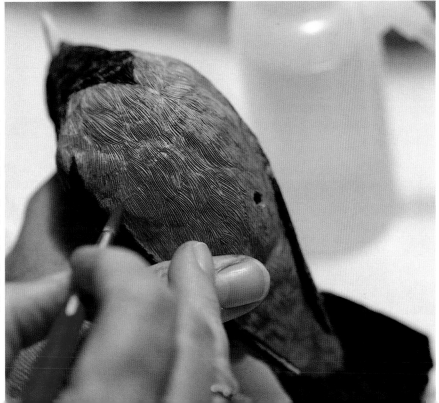

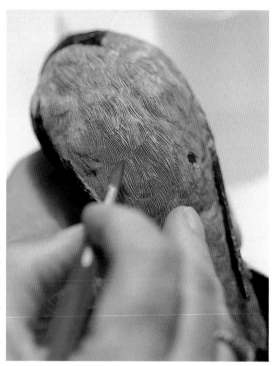

The purpose of these washes is to create the illusion of softness and depth, emphasizing the textures added during the carving process. Jo adds a thin wash of burnt umber to the edges of the feathers, which acts as a counterpoint to the gold highlights.

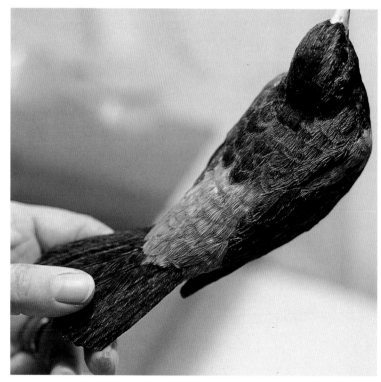

The back of the oriole looks a bit two-dimensional with just straight washes of gold, so Jo will add thin washes of burnt umber to the deep areas at the edges of the feathers, then create highlights on the centers of the feathers with additional applications of acra gold.

The back has more definition and richness now, with the addition of burnt umber and gold washes. "The operative word," Jo says, " is *thin*." The washes should be very, very subtle. You don't want the technique to call attention to itself. "The burnt umber wash darkens the low spots and helps add the illusion of depth and softness," she says. "I might go over it a half-dozen times, using very thin washes, being careful not to leave a hard edge."

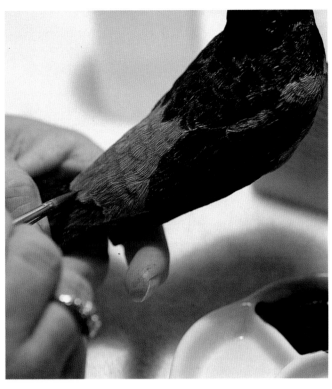

The bill is painted with thin washes of black, which Jo creates by mixing ultramarine blue with burnt umber, adding a bit of matte medium, which lends a leathery look. She tests the color on a piece of palette paper before applying it to the bird.

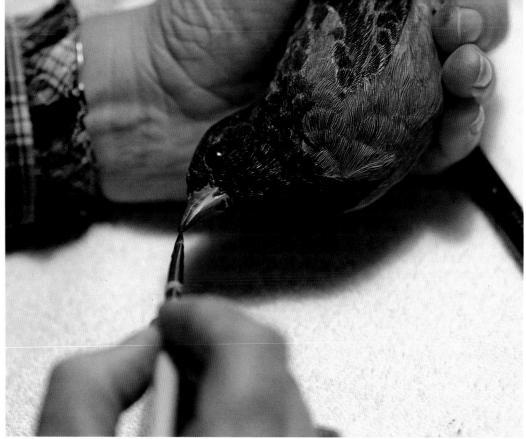

The orchard oriole has a small blue triangle on the lower bill next to the head, so this area will not be painted black. Jo begins the brush stroke at the head, ending at the tip of the bill. Several thin washes are applied, building the color gradually.

The triangle on the lower bill is a mix of cerulean blue and titanium white. Jo consults her reference photos to get as close a match as she can. A final wash of matte medium finishes the bill.

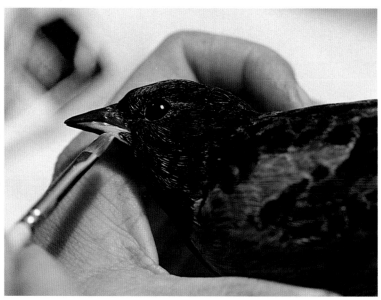

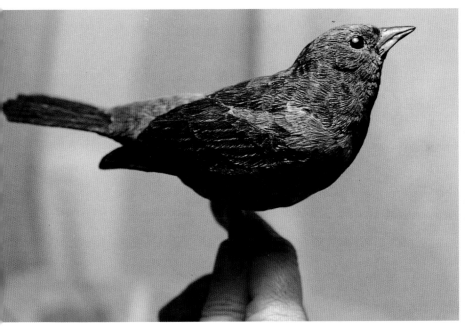

The preliminary painting is finished, and all that remains is adding the legs and feet and painting the white edges on the wing feathers. These edges were not painted when the black was applied.

Jo very carefully applies titanium white to the edges of the wings using the Sunburst brush. She consults reference photos to determine the locations of the white edges.

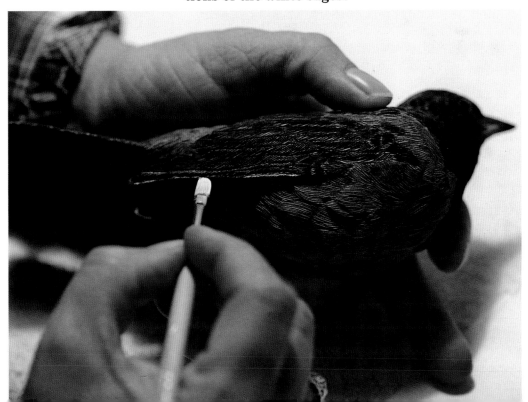

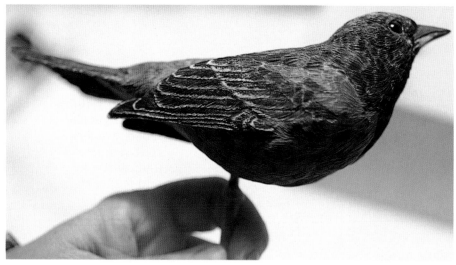

The white edges have been added, and the oriole is nearly finished. If the white wing edges are too stark, they can be subdued by applying a very thin wash or two of burnt umber.

Jo dries the finished oriole with the hair dryer; she will next mount and paint the feet and legs. She will also add a few subtle highlights by applying a tiny bit of gloss medium here and there. "That step will pick up the highlights of the burn lines. You certainly don't want a glossy bird, but a little gloss medium can add life. I dip the brush in gloss medium, then blot most of it off. It's almost a dry-brush technique."

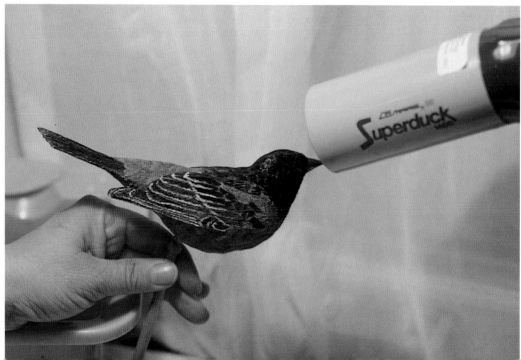

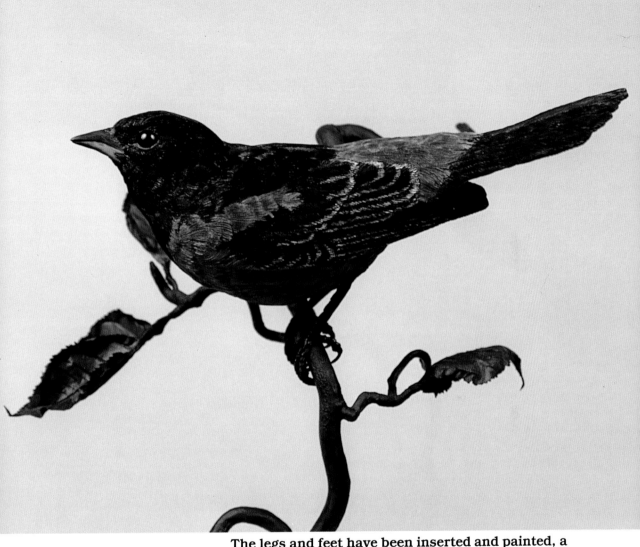

The legs and feet have been inserted and painted, a few more gold highlights have been added, and the bird is finished. Jo paints the legs and feet first with matte medium, then applies gesso. They then are painted with several washes of brown-black, the same mix of burnt umber and ultramarine blue used on the bill. A thin wash of white emphasizes the scales by lightening the texture lines. A final application of matte medium gives the legs a realistic, leathery look.

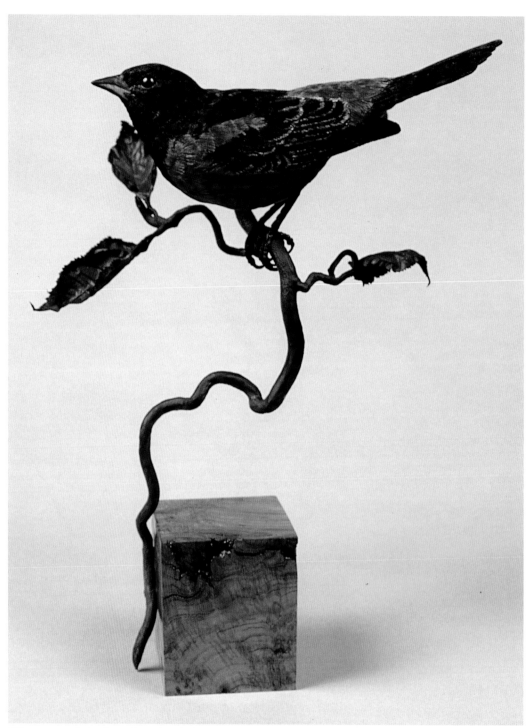

The completed orchard oriole.

6

Grayson Chesser
Painting a Canada Goose Gunning Decoy

It's difficult to determine whether Grayson Chesser, Jr., is a decoy maker who happens to hunt, or a hunter who happens to make waterfowl decoys. Hunting and decoy carving are closely interwoven passions for Grayson; one does not exist without the other.

Grayson grew up on a farm on Virginia's Eastern Shore and began hunting waterfowl when he was something like twelve years old. His father, a Virginia game warden, would drop Grayson off on a seaside marsh, and he would spend the day hunkered down in the cordgrass while his modest rig of decoys floated in a shallow pond. On good days, he would have a pair of black ducks for dinner when his father picked him up.

Grayson began carving as an extension of hunting. His battered old decoys needed fixing up, and he needed a few more for his rig. So necessity became the mother of invention. At the same time, he began to appreciate the skills of the old-time decoy makers whose stools he was using and repairing. He spent many hours with Miles Hancock of Chincoteague and other veteran craftsmen, learning the skills and studying the work of different makers. By the time he graduated from high school, Grayson had become a highly regarded decoy maker, and he had begun an excellent collection of classic decoys, which were just becoming collectible.

After earning a degree in business from Old Dominion University in Norfolk, Grayson returned to the family farm, growing potatoes in the summer and spending his fall and winter months making decoys and hunting waterfowl. He worked part time as a game warden and supplemented the farm income by guiding parties of visiting sportsmen.

Meanwhile, a market was growing for Grayson's decoys, not just among hunters but also among collectors who wanted his gunning birds for the display case. When the farm economy dipped in the seventies, Grayson sold his equipment and began carving full time, a move he has never regretted.

Grayson continues to make gunning decoys, although most of the decoys purchased by collectors never see the water. He still lives on the Eastern Shore farm, just a few miles from both the Chesapeake Bay and the Atlantic Ocean. The area is rich in the traditions of waterfowl hunting, and Grayson keeps this legacy alive. During the waterfowl season he spends many hours hunting black ducks and brant on the seaside, teal and mallards in the bayside creek near his home, and snow geese and Canada geese in soybean fields on the upland of the peninsula.

At season's end, you can find Grayson in his carving shop, using unsophisticated tools to make incomparable decoys that are at once contemporary and traditional.

In this session, Grayson paints a rig of five Canada goose decoys. These are gunning decoys, so they will be weighted to float properly and anchor line loops will be attached. The geese are carved in a variety of positions, because Grayson stresses the importance of considering the decoy rig as a whole, not simply as a collection of individual birds. In nature, wild geese will be found sleeping, feeding, preening, and carrying on with normal goose business. When making a rig of decoys, the goal should be similar to that when painting a picture: You want to create the impression of a group of happy, safe, contented birds.

Grayson uses a variety of oil paints for his goose decoys. First he seals the wood with pigmented varnish to provide a uniform painting surface, then he paints the breast with a mix of Ronan raw umber and white Rustoleum. Straight raw umber is used on the upper body, and the head and tail are painted with Rustoleum white and flat black. He applies two coats of these base colors, and when they have dried, he sketches in feather patterns and paints them with a mix of white, raw umber, and raw sienna. The bird is finished with a coat of non-gloss varnish tinted with a bit of raw sienna.

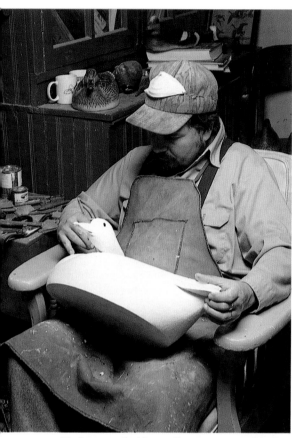

Grayson begins by having handy the various paints he will need: Ronan raw umber for the upper body, raw umber lightened with flat white Rustoleum, straight white Rustoleum to paint the white areas, and Rustoleum flat black. He begins by applying straight raw umber to the upper body.

Before painting, Grayson seals the wood with white pigmented varnish to provide a uniform painting surface. When the varnish has hardened, he sketches in the major feather groups with a pencil. These marks define the white cheek patch, the black along the neck, the wings, and the white rump. The pencil sketch is used as a guide during painting. Studying a photograph or a live goose will help you determine the color patterns.

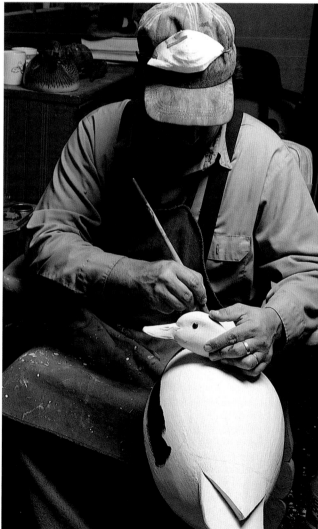

While the raw umber is still wet, Grayson applies light gray (raw umber lightened with white) to the breast and lower body, blending it to the straight raw umber to create a soft edge. It's important to apply the light gray value of raw umber before the dark area becomes tacky. Otherwise the two colors will not blend properly.

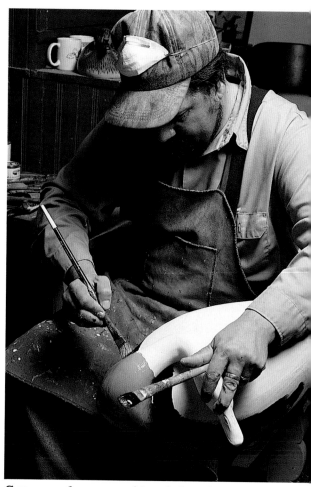

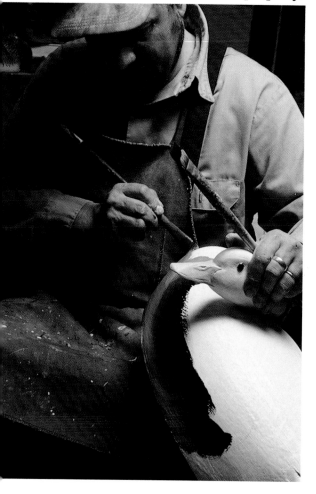

Grayson does one side of the bird at a time. It's handy to use two separate brushes for this step, one to apply the straight raw umber, the other to apply the lighter value and to blend it with the dark area.

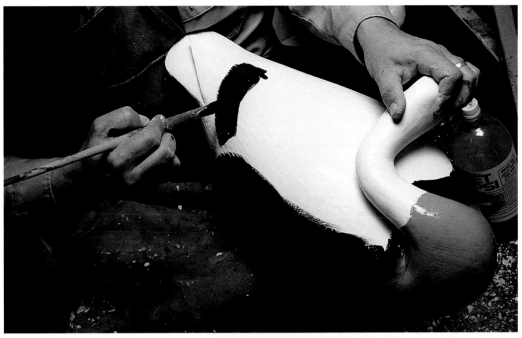

Next Grayson paints the back with straight raw umber. The wing tips and tail will later be painted black.

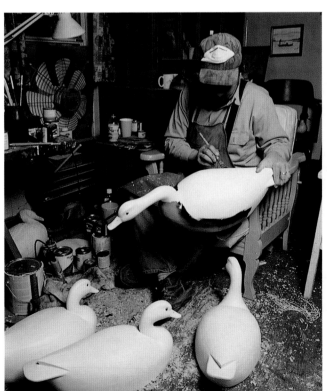

Grayson will be painting five birds during the session as part of a hunting rig. It would take a lot of time to paint each bird individually, so he will paint them all at once in sort of an assembly-line fashion. The first step is to apply the base coat to the breast and body of each bird. Grayson will apply two coats of the base color to each of the five geese. Notice the blended area along the side of this goose carved in a hissing pose.

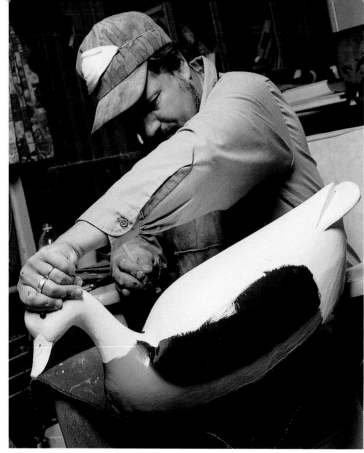

When painting the sides and breast, the immediate concern is blending the two values of raw umber where the paints meet. Grayson will paint the top of the body and the wings later. The Ronan paints are oil based, but they dry quickly, so time is of the essence. The paint job will be neatened up with the second coat.

As Grayson applies a coat of base color to each bird, it goes on a rack to dry. By the time he finishes the base coat on the fifth bird, the first one should be dry enough to handle, and Grayson can paint the other areas.

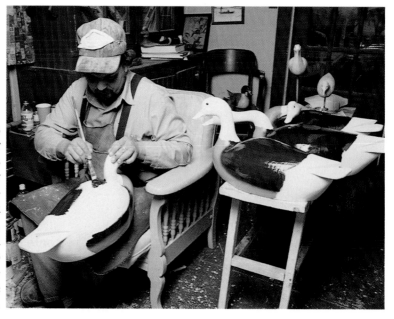

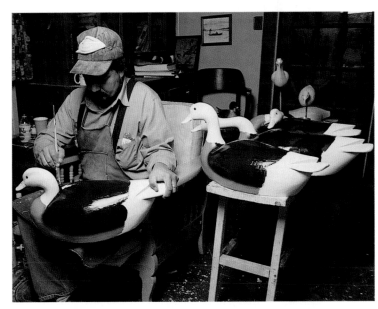

The base coat is nearly completed on the fourth bird. Grayson began this bird by painting the breast and lower sides, then working upward to the back. It takes him about twenty minutes to apply the base coat to each bird.

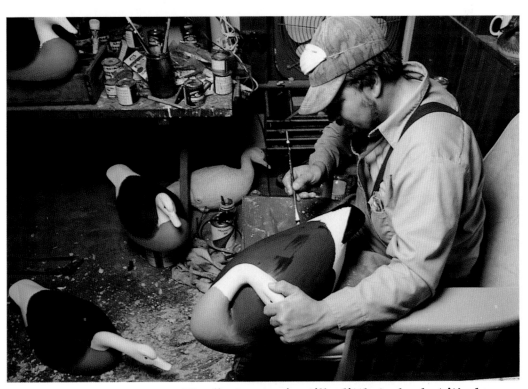

The first goose is still a little tacky, but it's dry enough that he can carefully paint the tail, wing tips, rump, head, and neck. He begins with the tail feathers, applying a coat of Rustoleum flat black.

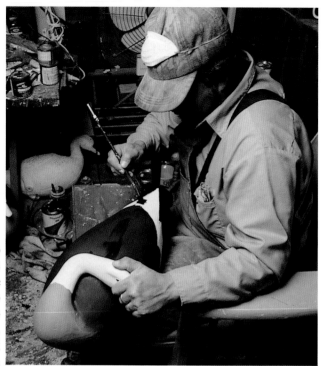

The black is also applied to the wing tips. This area was sketched in pencil before painting began. It's vital to begin with a sketch to diagram the paint pattern. It's a lot easier to erase pencil lines than to repaint.

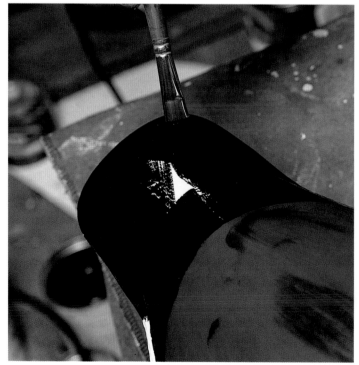

The tail is almost finished; Grayson applies a coat of Rustoleum to the underside. The paint appears glossy when wet but will dry to a flat finish. Always use flat finish Rustoleum, never gloss or semigloss.

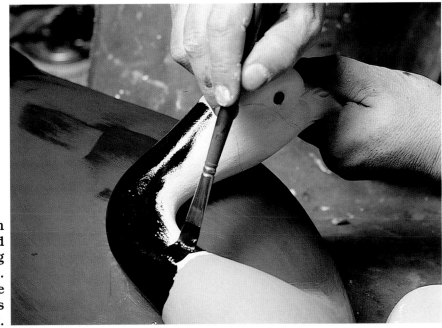

Now Grayson paints the head and neck using black Rustoleum. Note that the cheek patch has been sketched.

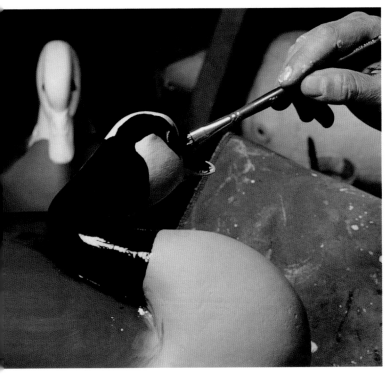

The head and bill are nearly finished on this decoy. The cheek patch will be painted white, even though the sealer already is white, because later a coat of varnish will be applied, and the varnish reacts differently over paint than over sealer.

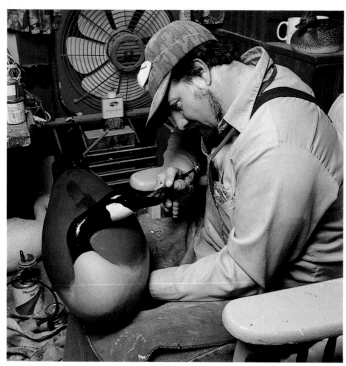

The head is just about finished on the first goose. The brown marks on the back of the bird are patches of tacky paint.

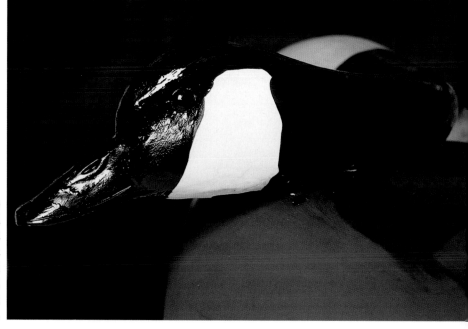

This close-up shows the head of the first bird. The paint is still wet and glossy. It will dry down to a flat finish.

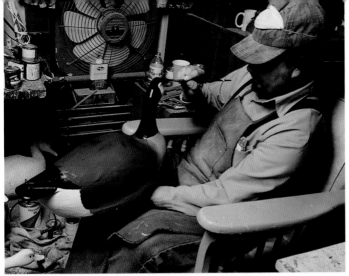

Grayson completes the second bird; he will follow the same procedure on the remaining three. The paint will be allowed to cure for at least twenty-four hours before a second coat is applied. Then, when the second coat hardens, he will add painted feather detail.

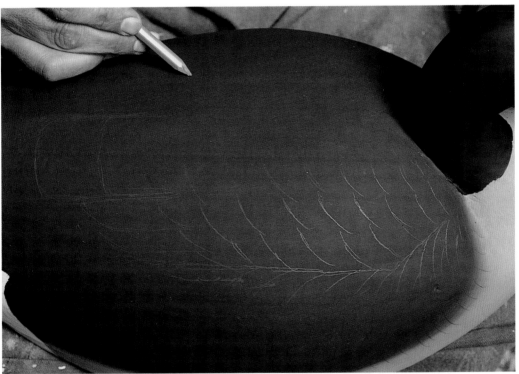

He begins by using a soft lead pencil to outline the edges of the feathers along the back and sides. These lines will serve as a guide when Grayson begins painting. He sketches the feather pattern from memory. If you're new to painting Canada geese, you might want to consult a sharp photograph or a taxidermy specimen.

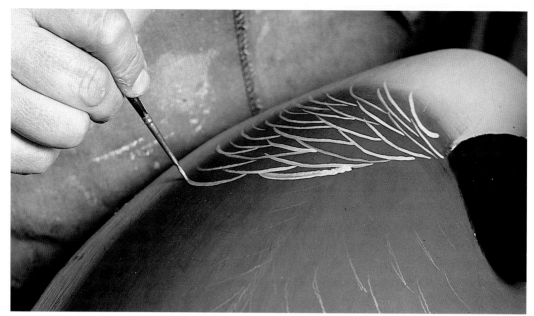

The feather edges are painted a cream color Grayson gets by tinting Rustoleum flat white with raw umber and raw sienna. He begins on the left front side of the bird, following the pencil marks. His next step will be to soften the inner edges of the feather marks; since this step must be done while the paint is still wet, Grayson paints only about one-third of the side at a time.

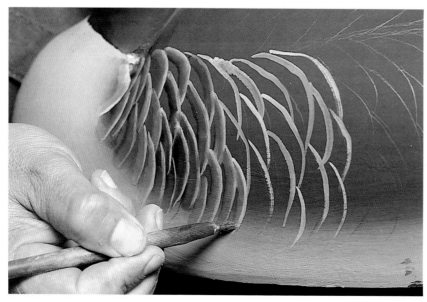

To soften, or blur, the inner edges of the feathers, Grayson uses a stiffer brush than the one used to apply the paint. He dips it into thinner, then dilutes the wet paint on the inner edges of the feathers, using the brush to soften the edge.

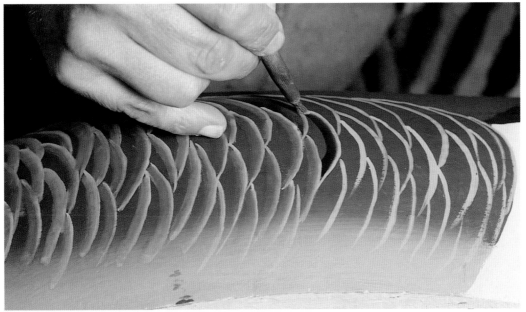

Grayson now does the final third of the left side, softening the edges of the feathers with paint thinner. Note how the feather edges extend into the light area at the base of the carving.

The process is continued on the back of the goose. Note the pattern of the primary and secondary feathers where the wings fold over the back. It's important to have the feather layout diagramed before you begin to paint.

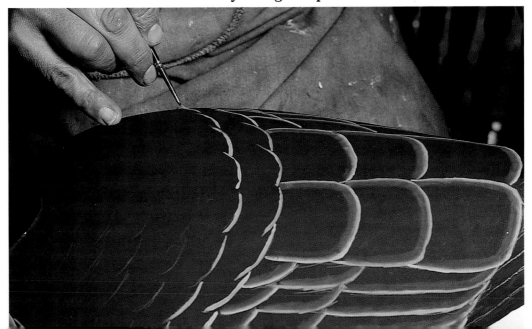

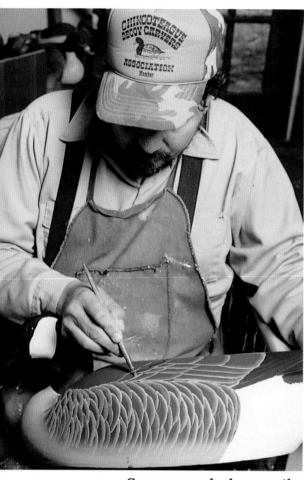

The back is almost finished, and this photo gives you a good idea of the pattern Grayson used on the wings and back of the bird.

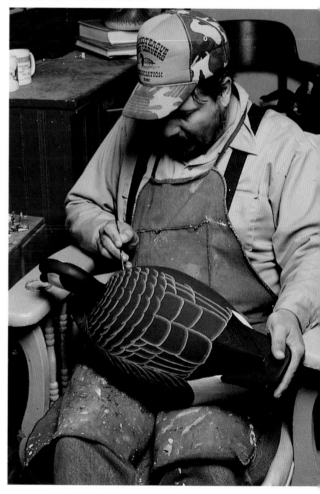

Grayson works here on the feathers on the back, softening the edges of the painted detail with thinner. He emphasizes the importance of doing only a small feather group at a time, so the paint will not dry before the thinner is applied. Different paints dry at different rates, and drying time depends upon temperature and humidity, so adjust your painting technique to fit your particular conditions.

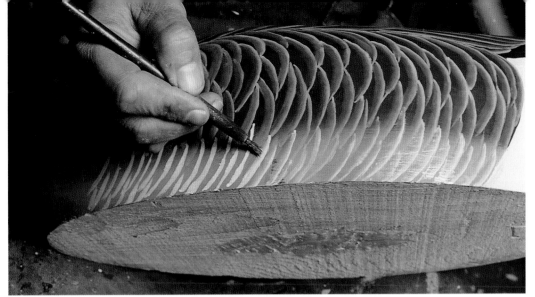

Before painting the right side of the goose, Grayson adds the feather edges on the bottom of the left side, using straight Rustoleum flat white, which shows up well against the lighter background. The white feather edges are applied in a random manner. He does not sketch a pattern in pencil before painting in this area.

The white feather edges are painted where the light value of raw umber was applied as a base coat: along the lower sides and up the breast. Here Grayson completes the lower side and prepares to add detail to the breast.

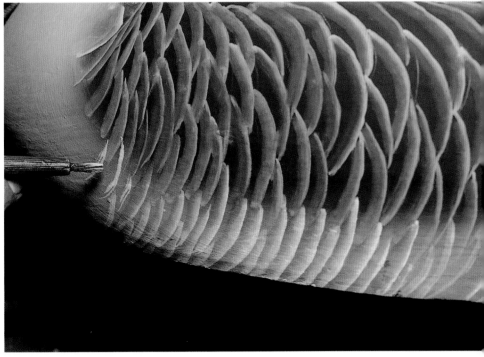

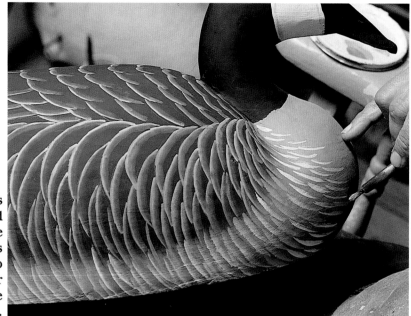

The breast is being painted now, and he carefully blends the detail into the darker areas of the side and back.

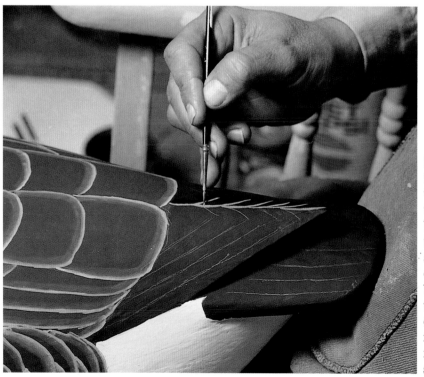

Next Grayson paints the edges of the wing feathers as they cross over the back, then paints the tail feathers. He sketches these details with a pencil before painting. He uses the cream color made by mixing white with raw umber and raw sienna.

Again, the inner edges of these feather marks are softened with paint thinner while the paint is still wet. Grayson does one side at a time so he can soften the lines before the paint begins drying. After completing the wing tips, he will paint feather edges on the tail, following the sketched lines.

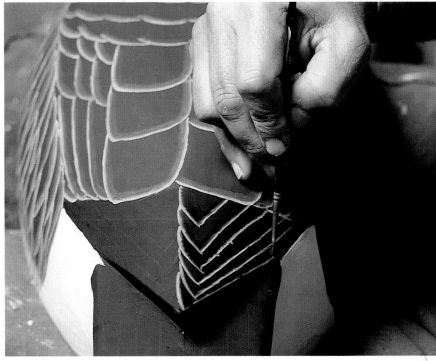

With all the feather edges painted, Grayson adds a bit of Rustoleum flat black to each feather on the back to give the impression of a quill. This is the final step in painting. Grayson will finish the bird with a coat of non-gloss varnish that has been tinted very slightly with a bit of raw sienna. This protects the paint, softens the contrast of the feather edges, and adds a bit of warmth to the whites. If the varnish is too reflective, he dulls it by rubbing with ground pumice.

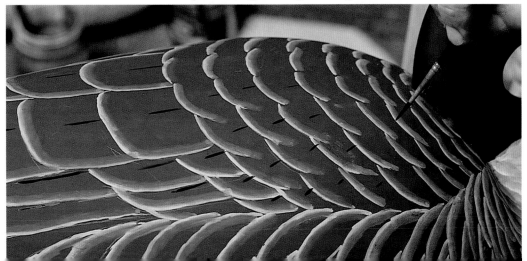

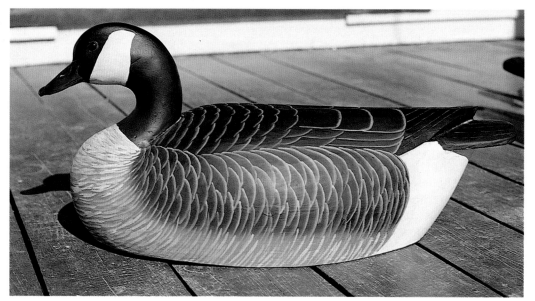

One of the completed geese, ready for a goose hunt—or, more likely, for someone's den.

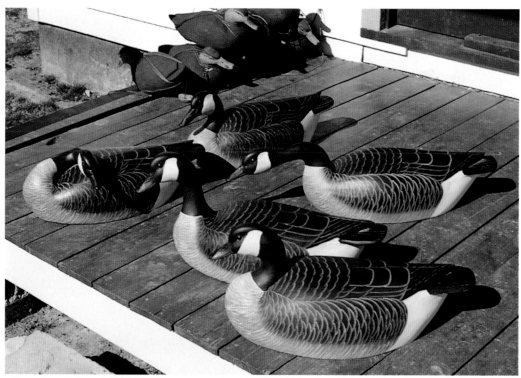

The rig of five Canada geese, each of which is carved in a slightly different attitude.

About the Author

Curtis Badger has written widely about wildfowl art, wildfowl hunting, and conservation issues in general. His articles have appeared in many national and regional magazines, and he serves as editor of *Wildfowl Art Journal*, which is published by the Ward Foundation. He is the co-author of *Painting Waterfowl with J. D. Sprankle* and is currently working on a book about salt marsh ecology.

Other Books of Interest to Bird Carvers

Songbird Carving with Ernest Muehlmatt
Muehlmatt shares his expertise on painting, washes, feather flicking, and burning, plus insights on composition, design, proportion, and balance.

Waterfowl Carving with J. D. Sprankle
A fully illustrated reference to carving and painting 25 decorative ducks.

Carving Miniature Wildfowl with Robert Guge
Scale drawings, step-by-step photographs and painting keys demonstrate the techniques that make Guge's miniature the best in the world.

Decorative Decoy Designs
Bruce Burk's two volumes *(Dabbling and Whistling Ducks, Diving Ducks,* and *Geese and Swans)* are complete guides to decoy painting by a renowned master of the art. Both feature life-size color patterns, reference photographs, alternate position patterns, and detailed paint-mixing instructions for male and female of twelve duck species.

Bird Carving Basics: Eyes
Volume one in the series presents a variety of techniques on how to insert glass eyes, carve and paint wooden eyes, burn, carve with and without fillers, and suggest detail. Featured carvers include Jim Sprankle, Leo Osborne, Pete Peterson, and Grayson Chesser.

Bird Carving Basics: Feet
Volume two features the same spectacular photography and detailed step-by-step format. Techniques for making feet out of wood, metal, and epoxy, creating texture and tone, and shaping feet in various positions.

Bird Carving Basics: Heads
Volume three illustrates how to create realistic head feathers by various methods, such as burning, wrinkling, stoning, and carving flow lines.

Bird Carving Basics: Bills and Beaks
Techniques such as burning and wrinkling, inserting a bill, using epoxy membranes, making open and closed bills and beaks, and carving the tongue are demonstrated.

Bird Carving Basics: Painting I
Full-color close-up photos illustrate painting methods in detail. Features techniques for vermiculation, iridescence, creating an aged patina, and painting in layers.

Bird Carving Basics: Habitat
Leaves, grass, water, snow, mud, fruit, plants—learn how to create realistic-looking habitat from wood, wire, metal, and epoxy.

For ordering information and a complete list of carving titles, write:
Stackpole Books
P.O. Box 1831
Harrisburg, PA 17105
or call 1-800-READ-NOW